Jaro Fabry

the art of fashion, style, and hollywood in the 1930s and 1940s

introduction by alex chun

HERMES
PRESS

neshannock, pennsylvania

Published by Hermes Press
2100 Wilmington Road
Neshannock, Pennsylvania 16105
(724) 652-0511
www.HermesPress.com; info@hermespress.com

Cover art by Jaro Fabry
Cover and book design by Daniel Herman
Cover and book design ©2008 Hermes Press
First printing, 2008

LCCN 2008930258
ISBN 1-932563-15-6

Image scanning by Graphic Collectibles and Brandi Budziak. The Estate of Jaro Fabry is represented by Mitch Itkowitz and Graphic Collectibles, 22 Blue Hills Drive, Saugerties, N.Y., 12477, 845.246.0952, mitkowitz@hvc.rr.com or visit www.GraphicCollectibles.com.

From Dan, Louise, Sabrina, and D'zur for Gort and Maya

ACKNOWLEDGMENTS

Special thanks to Mitch Itkowitz who made the artwork for this book available and Brandi Budziak who scanned the images. Also, a special note of appreciation to Alex Chun, Shane Glines, and Connie Woodard.

NOTE: the material in this book that was scanned from the original art is denoted by a description of the media used, all other illustrations were reproduced from the periodicals they appeared in.

Cover: Lana Turner, conte crayon and watercolor on paper. Opposite page: cover for *Collier's*, November 28, 1936, conte crayon and watercolor on paper. Overleaf: unknown magazine illustration, 1940s.

PUBLISHER'S NOTE

Back in the early 1960s my parents bought a grand, old, but somewhat run-down house in an estate sale. At the time our family had just relocated from the East coast to the Bay area of California. This particular house had been built after the great San Francisco earthquake of 1906 and had an attic full of books, magazines, and other bric-a-brac with an emphasis on the period from the 1920s through the late 1950s. I combed through these many dusty, dingy treasures for the three years we lived there and came away with a life-long affection for the great high fashion magazines and literary journals of those long-passed eras. It was through these books and magazines that I was first exposed to the art of, among others, John Held, Peter Arno, and Jaro Fabry. These artists, who contributed so much to the style and tone of the 1920s and 1930s have fallen out of fashion in these very different times. Hopefully this book will rectify that situation and bring Fabry's art, wit, and style to a new audience.

— *Daniel Herman*, Publisher

Printed in China

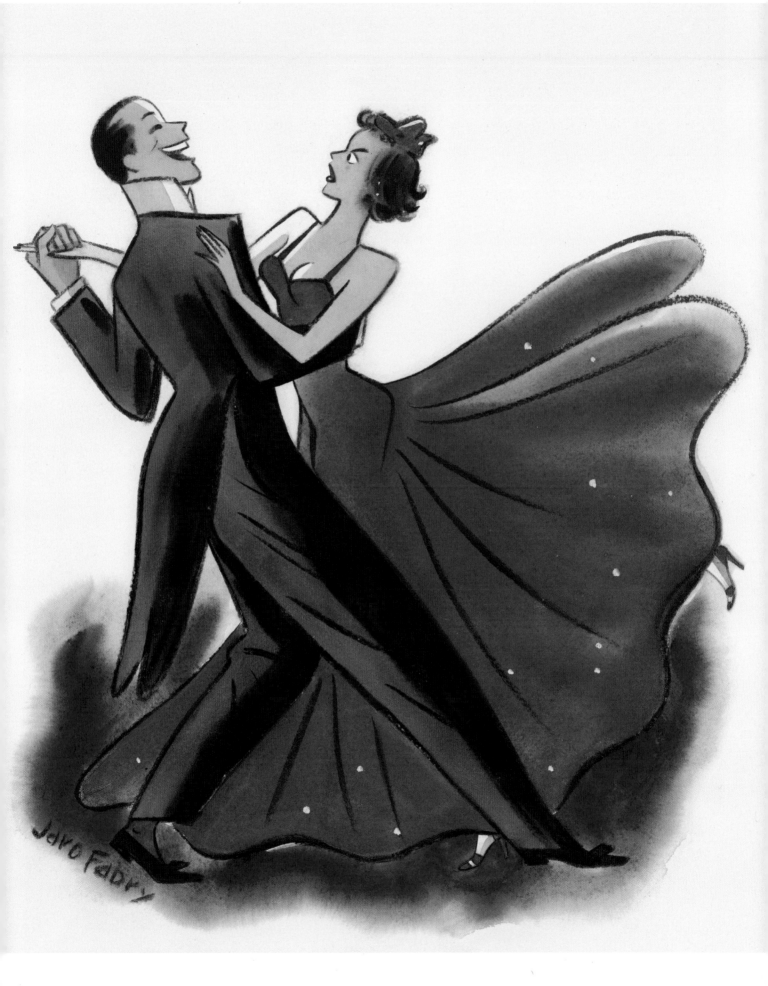

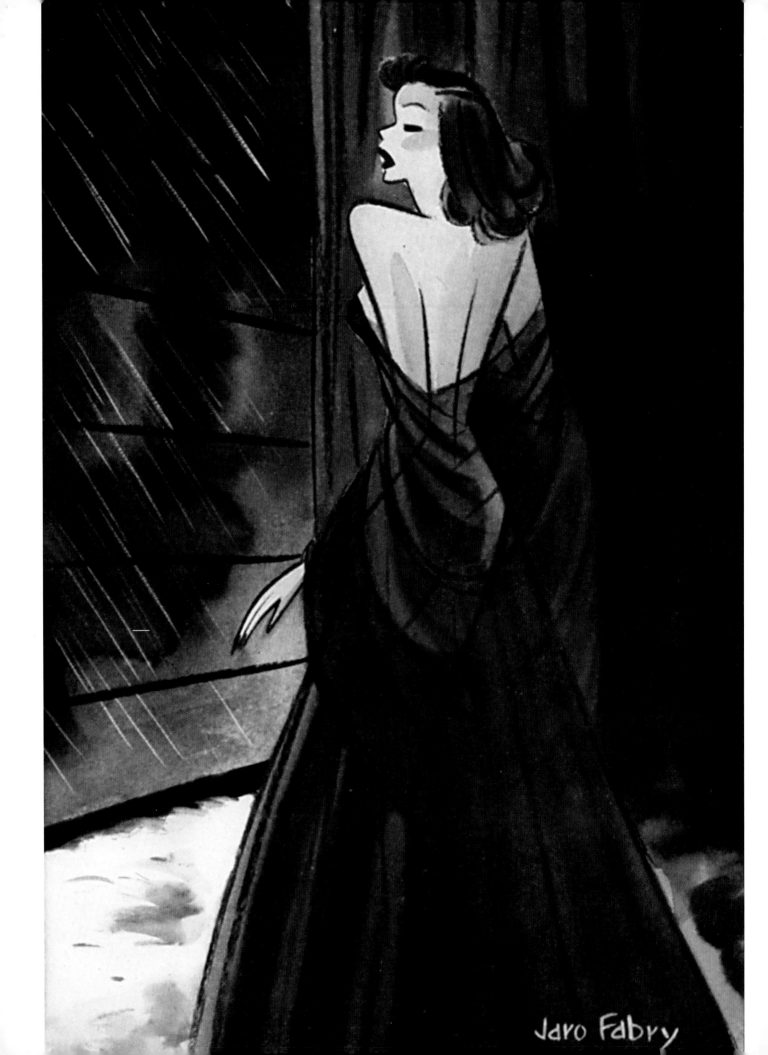

contents

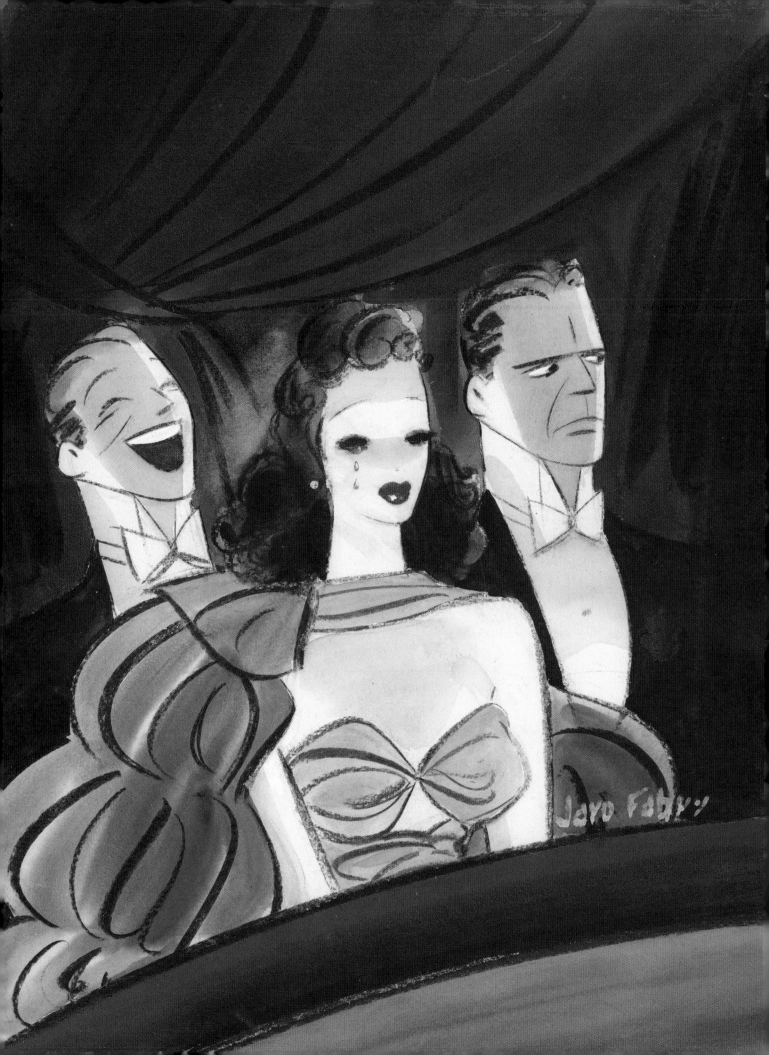

introduction

the art of fashion, style, and hollywood in the 1930s and 1940s

During the last two decades, illustration — read commercial — artists have finally begun to receive their just due. More than just pretty pictures on and in magazines, original works by illustration artists, particularly those from the first half of the 20th century, are now rightly seen as an indispensable part of Americana, garnering exhibitions in fine art institutions and hammer prices upwards of $15 million at auction.

When discussing illustration artists, luminaries such as Norman Rockwell and J.C. Leyendecker with their unforgettable *The Saturday Evening Post* covers quickly jump to the forefront, but more recently, art historians and aficionados have begun to recognize additional artists as visual caretakers of the early 1900s.

At the turn of the century, Charles Dana Gibson's "Gibson Girl" set the standard for the feminine ideal while John Held, Jr.'s flappers and Russell Patterson's Kohl-eyed beauties captured the white-hot jazz age of the 1920s.

Unused cover painting for the March 29, 1941 issue of *Collier's*, conte crayon and watercolor on paper.

Which leads us to the 1930s and artist Jaro Fabry.

The 1930s were marked by the end of prohibition, and despite the Depression, a vibrant New York nightlife populated by the famous and well-to-do. With her stylish evening dresses and alabaster skin, and accompanied by men in tuxes, the "Fabry Girl" represented all that was New York high society, a world that Fabry himself frequented. At hip joints like the Algonquin Hotel's supper club and the El Morocco, he was often seen escorting debutantes and starlets and sharing tables with Hollywood's elite.

Welding a brush that rendered a bold line and saturated his images with vibrant blues, yellows, greens and reds, Fabry translated his experiences to the cover and pages of top-tier magazines, creating often moody but always glamorous full-color paintings for the likes *Esquire*, *Life*, *Harper's Bazaar*, *The Saturday Evening Post* and *The New Yorker*.

Despite his status as one of the in-demand artists of the 1930s, surprisingly little is know about Fabry. Born Jaroslav Fabry in

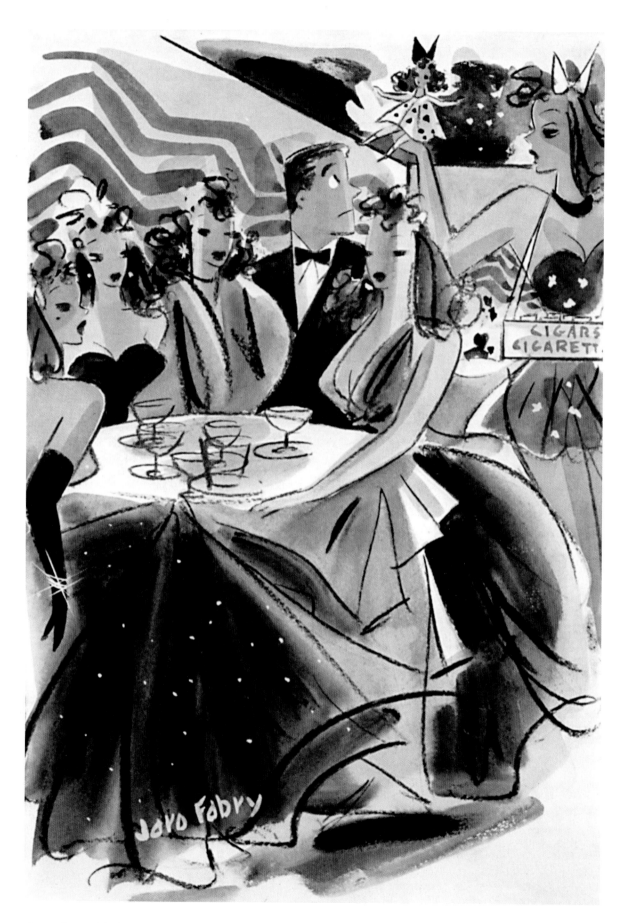

Jovo Fabry

1912, he grew in the Bronx amongst a family of artists. His father, Alois, a Czech immigrant, was a photographer and a portrait painter while his mother, Bozena, stayed home to take care of Jaro and his two siblings. His older brother Alois, Jr., also became an illustrator and cartoonist for national magazines; in contrast, his younger sister, Anica, never entered the applied arts, but she did model at the 1939 World's Fair, and more importantly, was the inspiration for Jaro's trademark "Fabry Girl."

Like his brother, Fabry received a bachelor's degree of Fine Arts from Yale University (1933) where he was a frequent contributor to *The Yale Record*, the campus humor magazine and the oldest college magazine of its kind. In addition, he also studied at the Art Students League of New York under the tutelage of George Grosz.

After finishing college, Fabry contributed gag cartoons to the likes of *College Humor*. That gig, however, came to an end, at least temporarily, in 1936 when the Cartoonist Guild of America, of which Fabry was a member, blacklisted *College Humor*, *The Rockefeller Center Weekly*, *The Voyager*, *Promenade*, *Movie Humor* and *Real Screen Fun* for not meeting its stated minimum fee of $15 per comic drawing.

In addition to gag cartoons, Fabry also created caricatures, advertising art and illustrations (which often accompanied non-fiction features about fashion, Hollywood types and society columns) for magazines such as *True*, *This Week*, *Cosmopolitan* and *The Saturday Evening Post*. He also designed several theater sets and produced a handful of record album covers and pocketbook covers.

Fabry's best work, however, was reserved for the covers of magazines like Charles Dana Gibson's *Life*, *Harper's Bazaar*, *The New Yorker* and *Cinema Arts* (for which he created a striking portrait of Katharine Hepburn). In addition to producing covers for these high-profile publications, he also

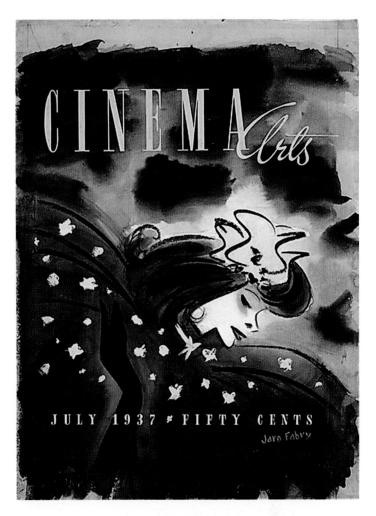

turned in gorgeous full-color, full-page (and even double-page) cartoons for *Esquire*. His first work for *Esquire* appeared in 1937, and a brief bio that accompanied that cartoon noted that the 25-year-old's avocations included "hot piano playing (a passion he shared with his sister) and night-club dancing—and just plain night club sitting."

So not only did Fabry illustrate the nocturnal goings-on of New York's privileged (his art often accompanied Lucius Beebe's Café Society column), he lived that life as well.

Dapper and boasting movie-star good looks, Fabry was often seen escorting debutantes or starlets into upscale nightclubs

Above: artwork for the cover from *Cinema Arts*, July, 1937, conte crayon and watercolor on paper. **Opposite page:** *Esquire* cartoon, 1940s, conte crayon and watercolor on paper.

Collier's

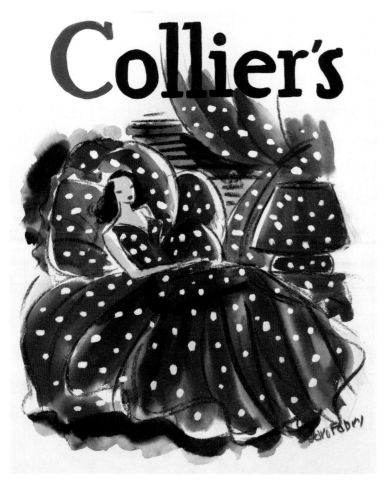

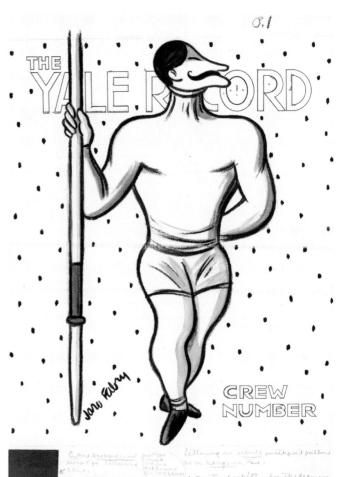

and restaurants such as the Algonquin's supper club, El Morocco, the 21 Club, the Stork Club, Coq Rouge and the Colony. As a result, he himself also was mentioned in the gossip columns, particularly those written by Walter Winchell and Dorothy Kilgallen. In 1940, a *Time* magazine article referred to Fabry as a "glamour boy" alongside "Billy" Livingston and Heinrich Orth-Palavicini.

Fabry's favorite haunt was the El Morocco Club, for which he created art for menus, advertisements, Christmas cards, ashtrays and even a mural. Located on East 54th Street near Lexington Ave., the El Morocco was a scene for the rich and famous from the 1930s through the 1950s.

At the El Morocco, Fabry would rub elbows with the likes of Hepburn, Lucille Ball, Douglas Fairbanks, Jr., Lana Turner and Greta Garbo, and if the mood struck him, he'd work up a sketch. Later, he'd go back to his studio in

the city (or his mother's home in Yonkers) and transform the sketch into a finished watercolor painting while listening to recordings of Thomas Wright "Fats" Waller or Eddy Duchin.

By 1941, Fabry was often seen in the company of starlet Adrienne Ames, who made 30 films during the 1930s, most notably *George White's Scandal* (1934) starring Rudy Vallee and Alice Faye. At around the same time, he toyed with moving into animation by accepting a six-week position with Walt Disney Studios to work on the animated feature *Fantasia*.

The job as well as his relationship with Ames (they were later rumored to be engaged) were put on hold, however, as Fabry, like most

Left: *Collier's* **cover from the late 1930s, conte crayon and watercolor on paper. Right:** *The Yale Record* **cover, late 1930s, conte crayon and watercolor on board. Opposite page: El Morocco advertisement, December, 1942.**

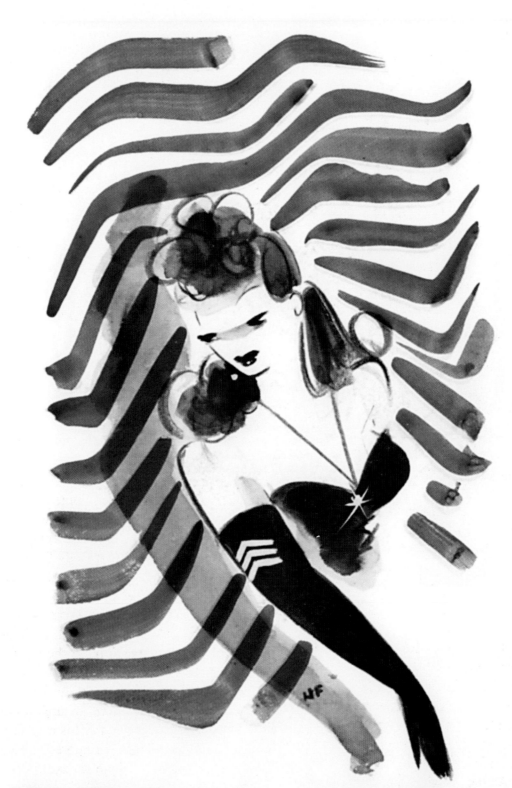

"EL MOROCCO" DECEMBER 1942

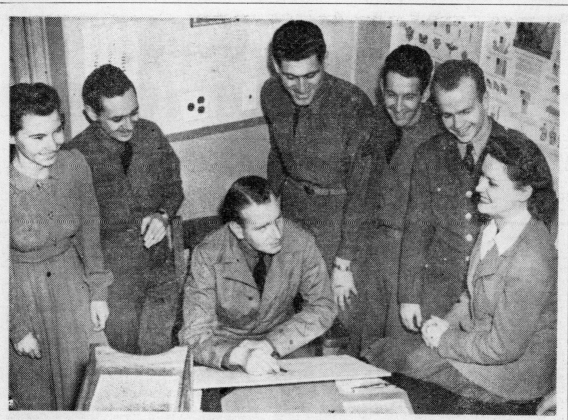

Or
Fro

CAMP
gram of t'
week ap
their d
Looking
compared
ago in nc
General O
have slow
we wil'
missio:
tion b
further
neuvers
without
cution tha
two years
General
mered ho
Japanese
thus able
of attack
then con
force for
lected has
importanc
As a resu
made des
the succes
Japanese.'
In order
might neve
a battle in.
General Or:
troops must
absolutely refu

JARO Fabry, the man who draws those purple-dressed women on magazine covers, is a private in the Signal Corps now. Here he is sketching stenos at Fort Belvoir, Va. (Some thrill, kid!) Left to right: Mrs. Horton, Pfc. Art Grover, Sgt. Frank Katz, Pfc. Max Ticker, Sgt. Ray Scott and Martha Willis. Soldiers are staff members of the Belvoir Castle.

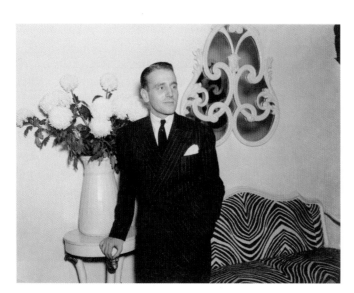

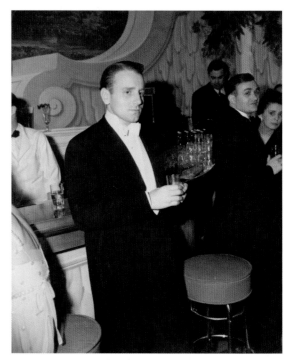

Top: clipping from the *Army Times*, March 28, 1942.
Below: two photographs from the early 1940s.

able-bodied men of his time, found himself caught up in WW II. Fabry enlisted in the U.S. Army on March 13, 1941, and soon after was stationed at New Jersey's Fort Monmouth where many illustrators and moviemakers served.

As it turned out, not even WW II could stop Fabry from painting, and as part of Company 2, 15th Signal Service Regiment, Private Fabry created War bond posters for the Army. In addition, he created a number of award-winning war-themed images that were later exhibited at Washington, D.C.'s National Gallery of Art and New York's Museum of Modern Art.

After the War, Fabry returned to magazine illustrations, but instead of covers and full-page color cartoons, he was mostly relegated to doing small ink-wash gag cartoons. These cartoons often ran a quarter page or smaller in the back of *True*, *Collier's*, and *The Ladies Home Journal*.

"While it's possible that the switch from illustrator to cartoonist was his decision, it's much more likely that he didn't have a choice," says animator and art historian Shane Glines. "The cartoon style favored by artists like Fabry, Hurst and Patterson seemed to lose favor with magazine editors as they turned to straighter, more realistic illustrators like Al Parker, Coby Whitmore and Jon Whitcomb."

Fabry painted until his unexpected death on February 17, 1952. He died in his home in Bronxville, possibly from malaria, which he purportedly contracted during the War. When he passed away, he left behind his parents, and his brother and sister. He never married.

Along with the National Gallery and the Museum of Modern Art, a *New York Times* obituary on Fabry noted that his work had been shown at New York's Metropolitan Museum of Art.

More recently, his Hepburn image for *Cinema Arts* magazine was included in an exhibition at the Library of Congress's Swann Gallery titled *American Beauties: Drawings from the Golden Age of American Illustration.* The show, which ran in 2002, featured original drawings that exhibited idealized types of feminine beauty by the likes of Gibson, Patterson, Held, James Montgomery Flagg, E. Simms Campbell, Peter Arno and Harry Beckhoff.

Fabry "employed a modernist approach related to Held's and Patterson's beauties in creating his drawing of Katherine Hepburn for the cover of *Cinema Arts*," wrote Martha Kennedy, the exhibition's curator. "Applying watercolor with loose, free brushwork, Fabry achieves a fresh spontaneous portrayal of Hepburn. Thoroughly all-American, she is a fitting choice to appear as an icon. She personifies a singular, individual beauty, yet projects star quality and universal appeal."

Like no other artist of his era, Fabry chronicled the great stars of Hollywood and captured the style and romance that was New York high society. Though it's been more than 50 years since his passing, his strong composition, bold confident line and striking use of color continue to inspire as his work is discovered by a new generation of artists.

— *Alex Chun*

chapter one
magazine covers

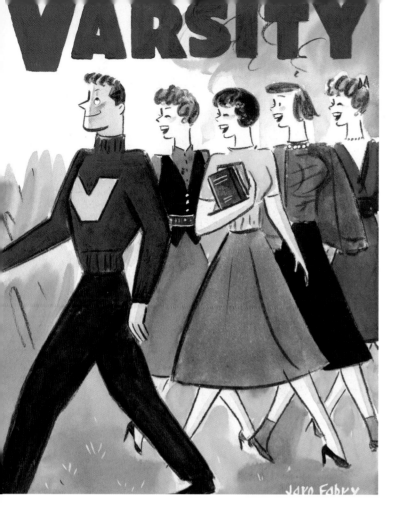

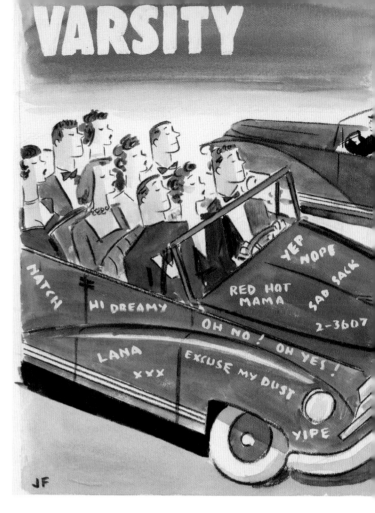

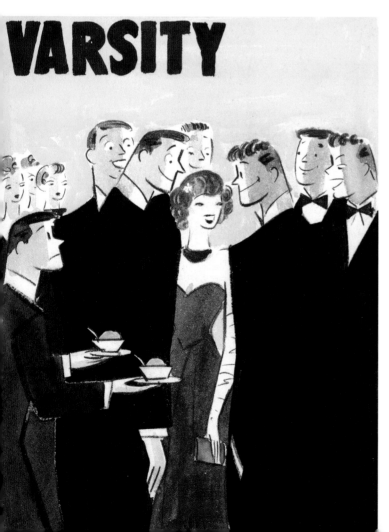

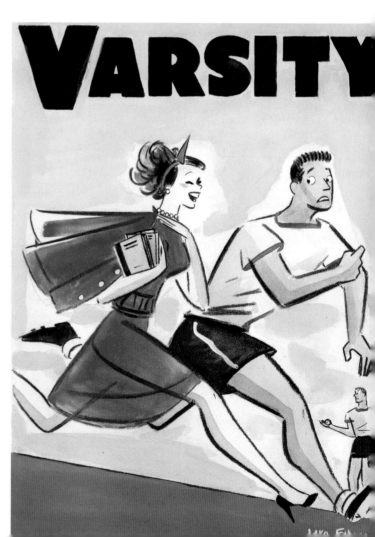

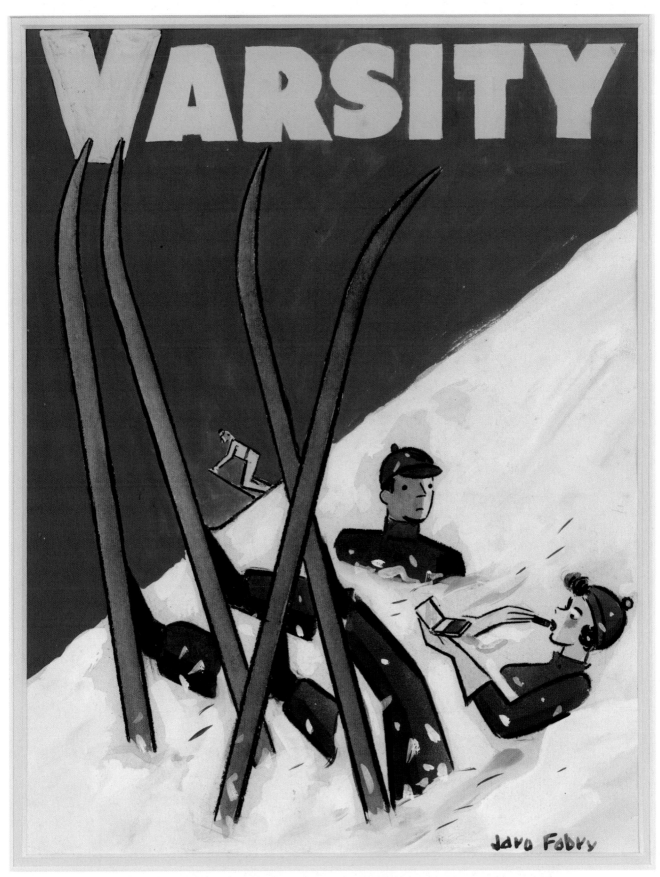

Previous pages: *Collier's* cover, February 26, 1938, conte crayon and watercolor on paper.
Opposite page and above: five *Varsity* magazine covers, all 1940s, watercolor on paper.

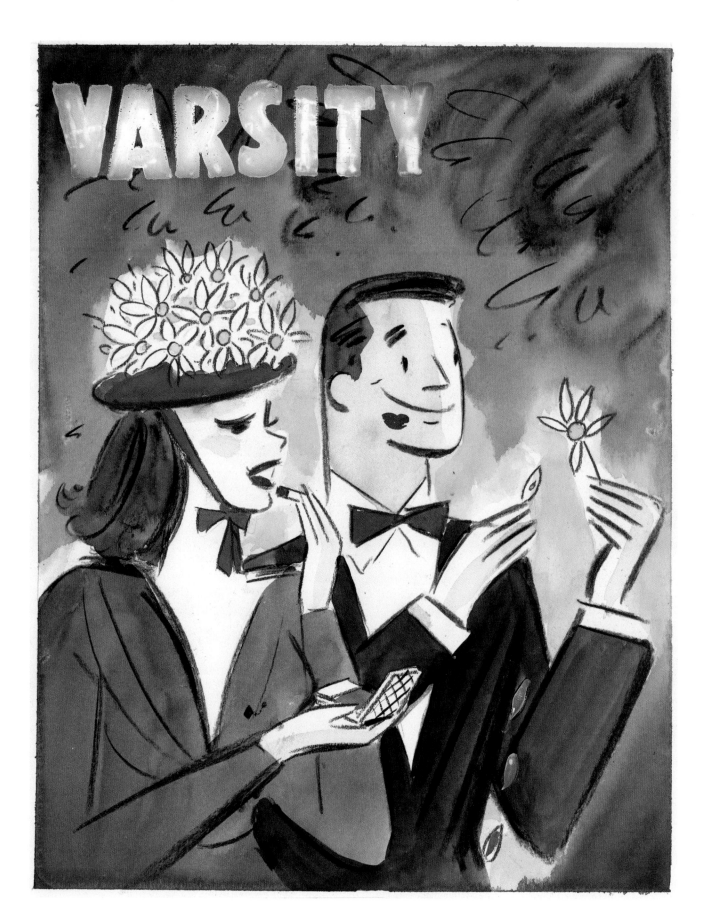

the art of fashion, style, and hollywood in the 1930s and 1940s

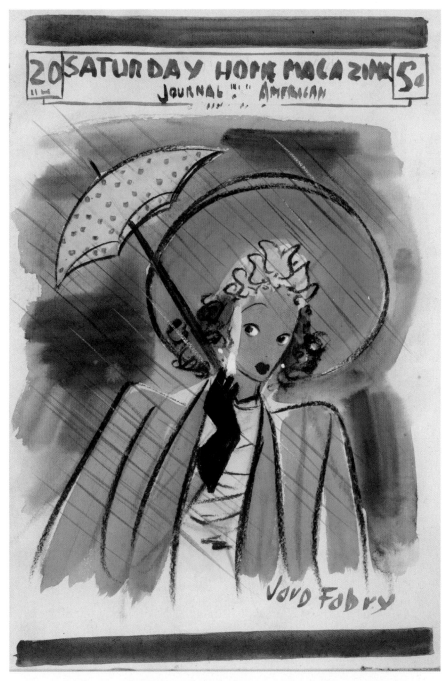

Above: sketch for a *Saturday Home Magazine* cover, 1940s, watercolor on paper. Opposite page: *Varsity* magazine cover, 1940s, watercolor on paper.

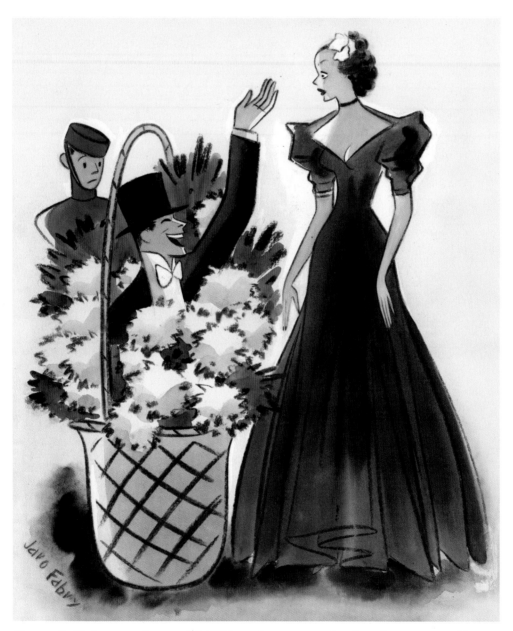

Above: *Collier's* cover, January 30, 1937, conte crayon and watercolor on paper. Opposite page: pocket book cover for *The Night Life of the Gods*, 1948, watercolor on paper.

Overleaf: Unused cover painting for the March 29, 1941 issue of *Collier's*, conte crayon and watercolor on paper.

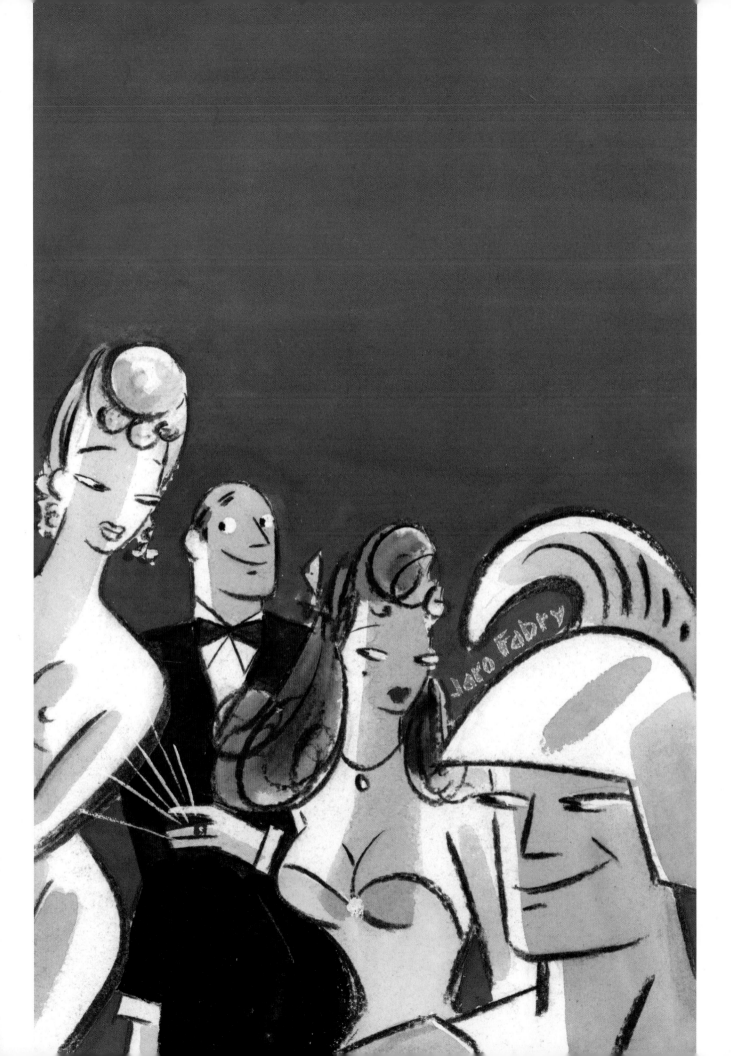

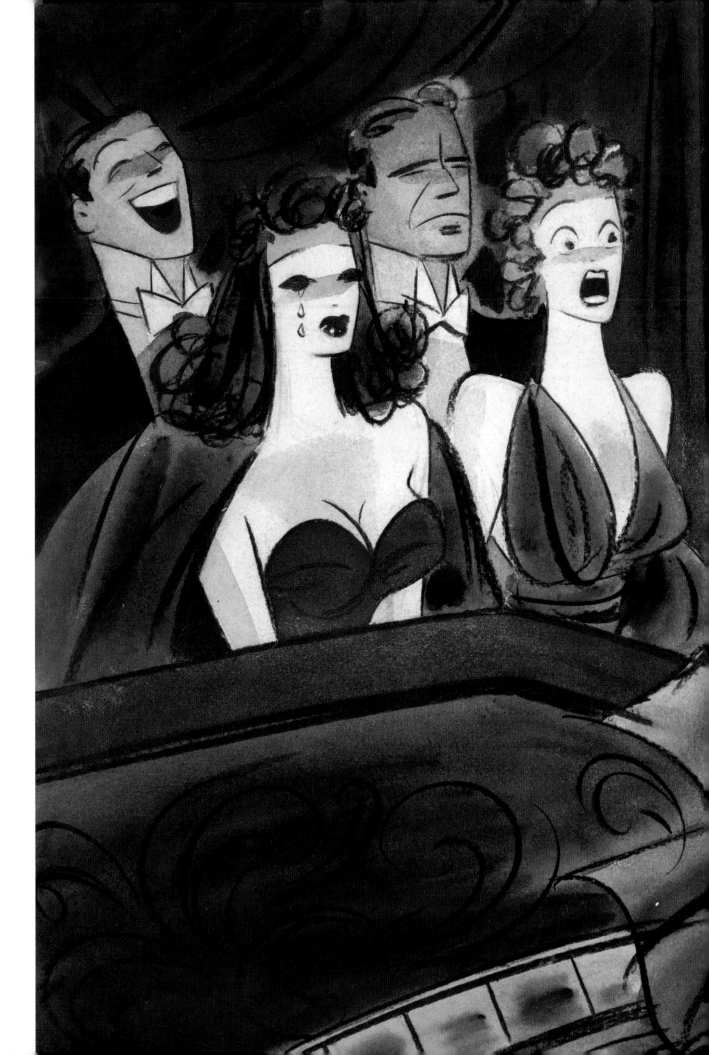

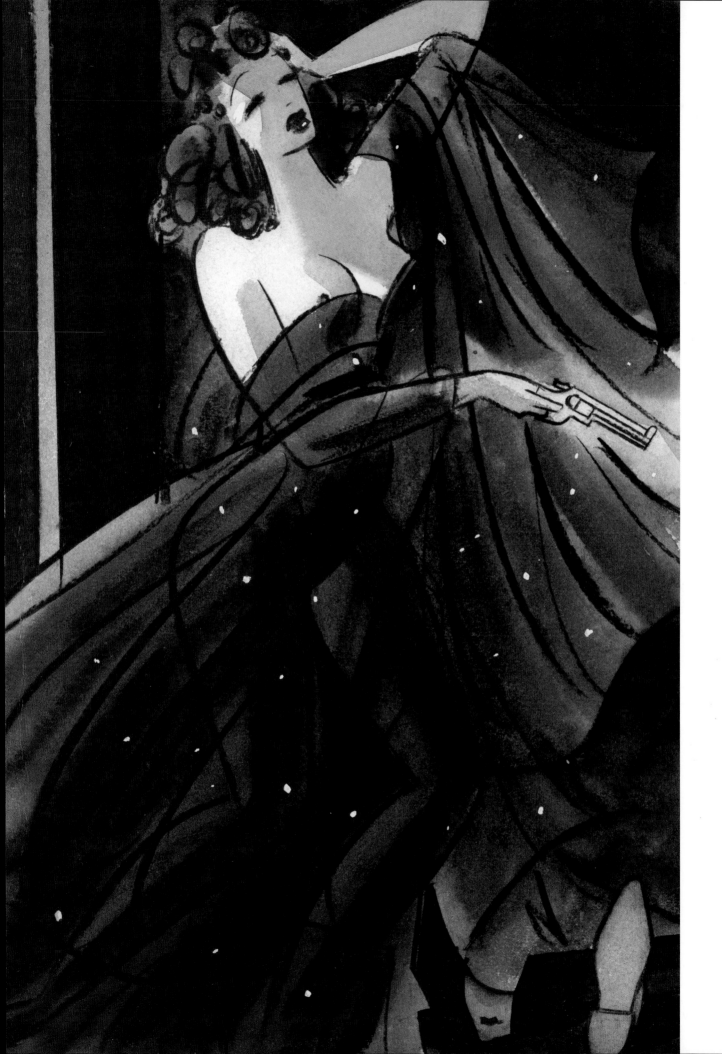

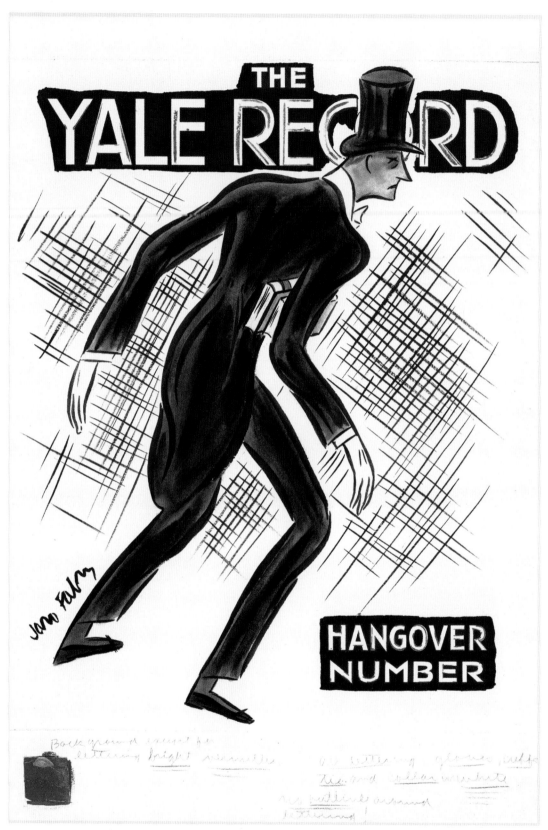

Above: *The Yale Record* cover, watercolor on board. Opposite
page: *Collier's* cover, January 1, 1938, watercolor on paper.

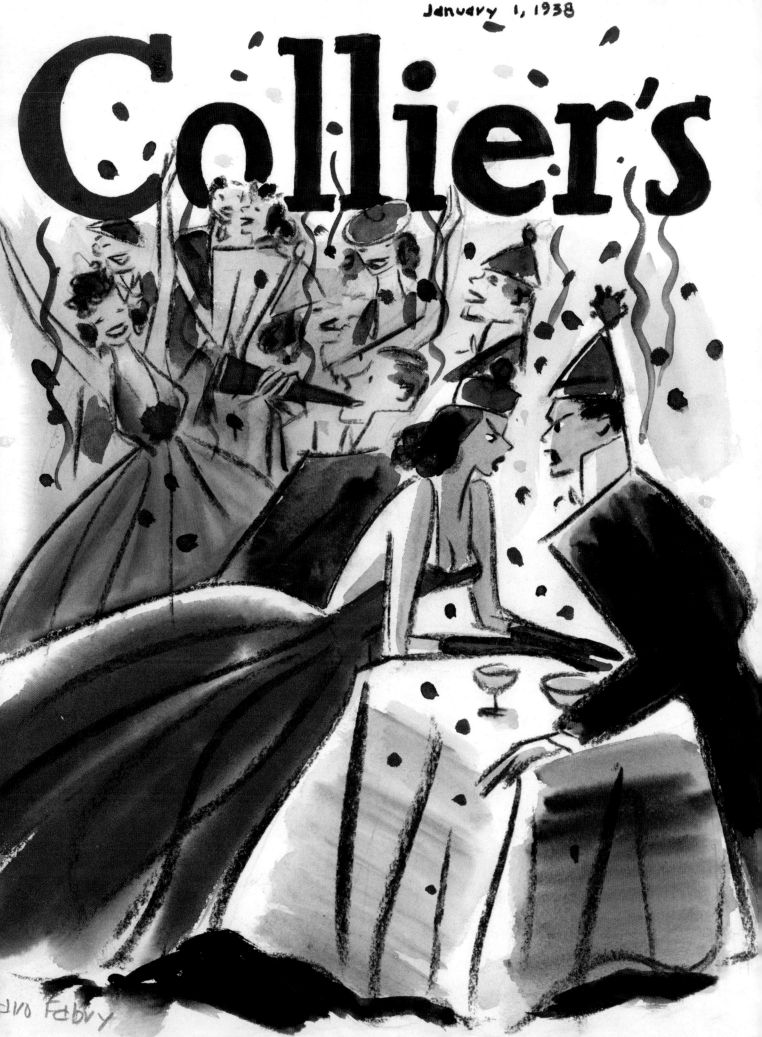

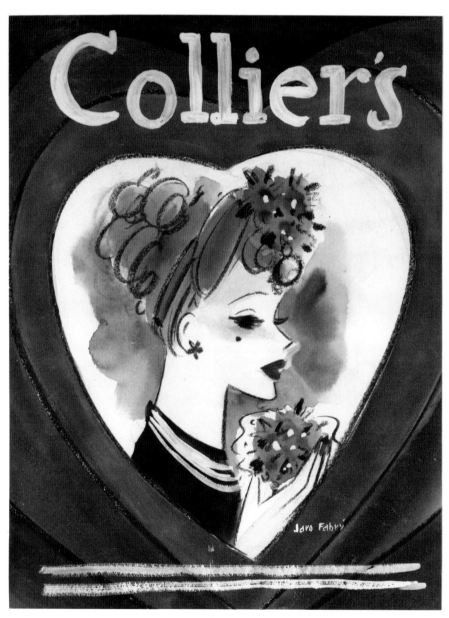

Above: *Collier's* cover study featuring Lucille Ball, 1940s, conte crayon
and watercolor on paper. **Opposite page:** *Collier's* cover, September
25, 1937, conte crayon and watercolor on paper.

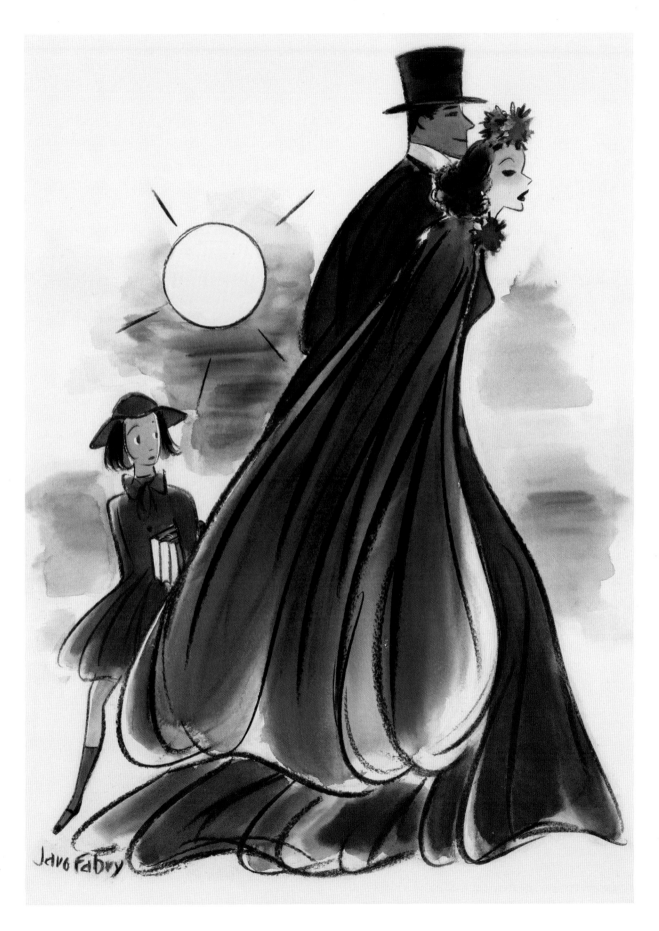

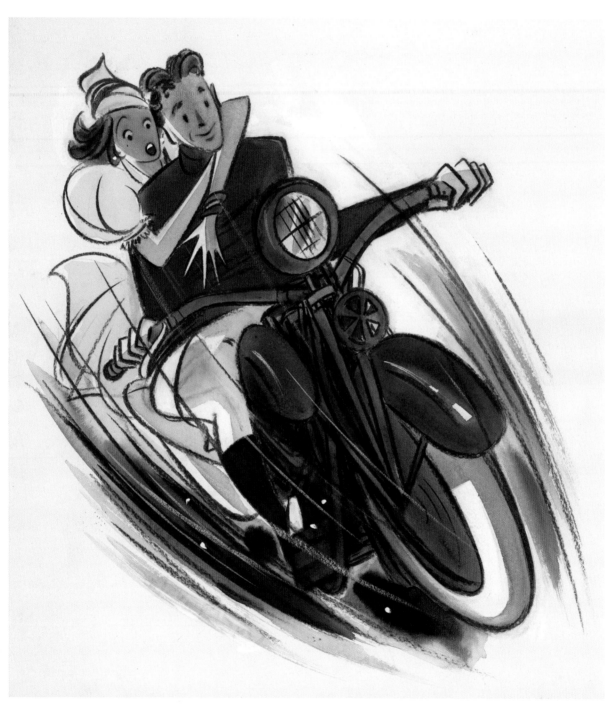

Above: *Collier's* cover, May 29, 1937, conte crayon and watercolor on paper.
Opposite page: unknown magazine cover, crayon and watercolor on paper.

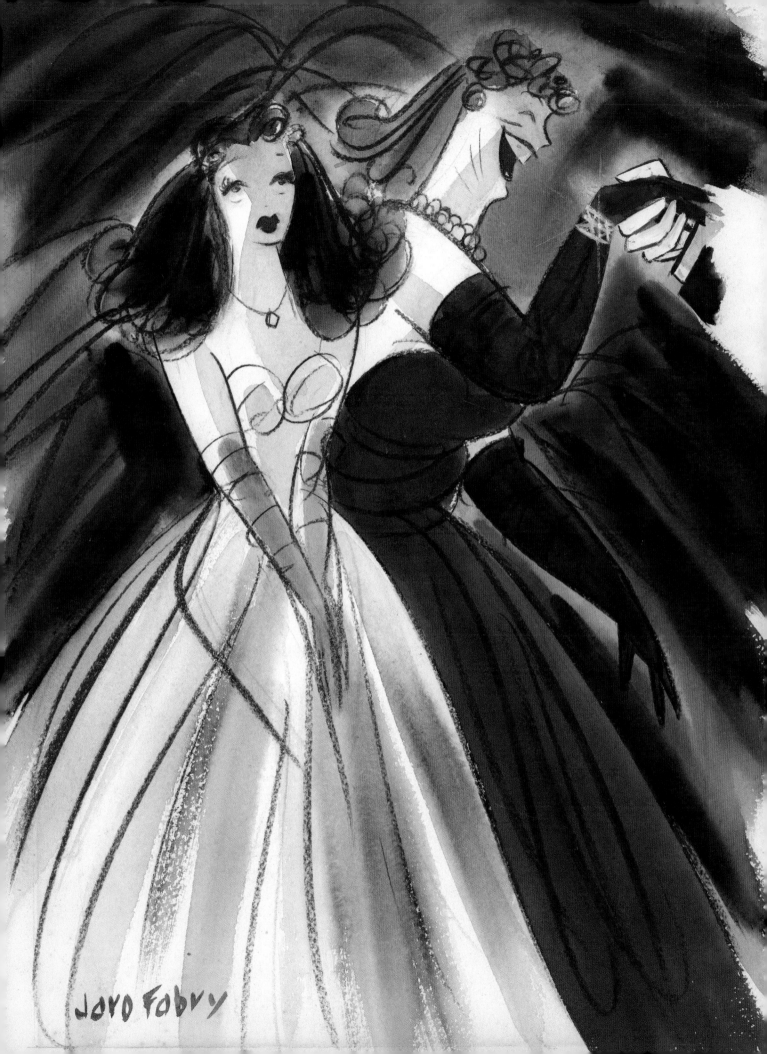

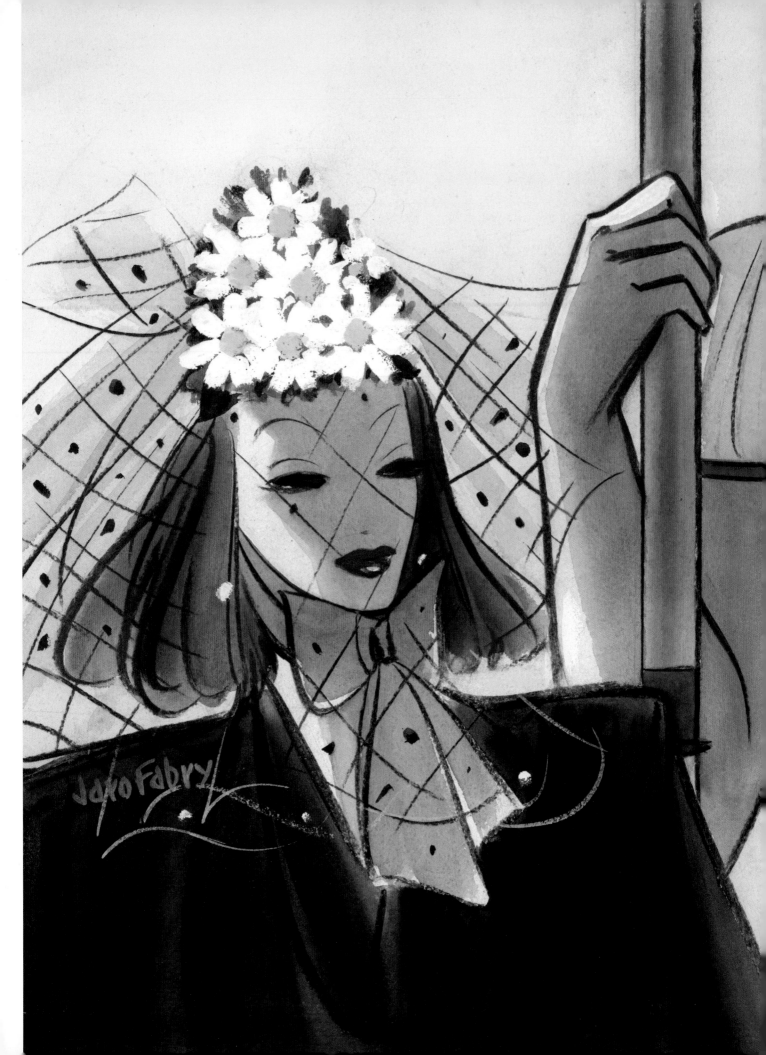

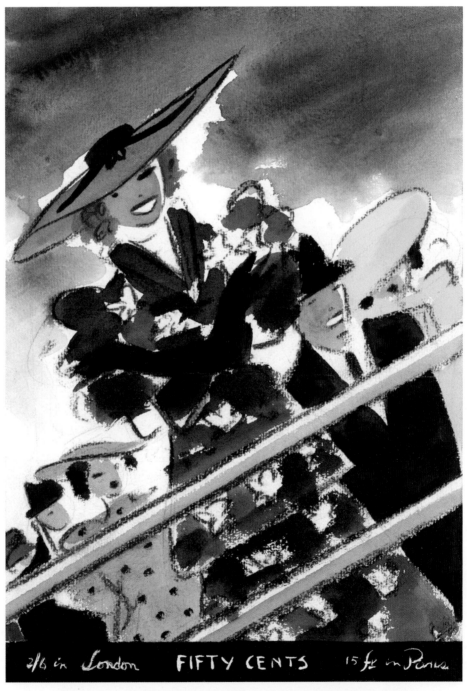

Above: *Havard Yale Regatta Magazine* cover sketch, late 1930s, conte crayon and watercolor on paper. Opposite page: unknown magazine cover, conte crayon and watercolor on paper.

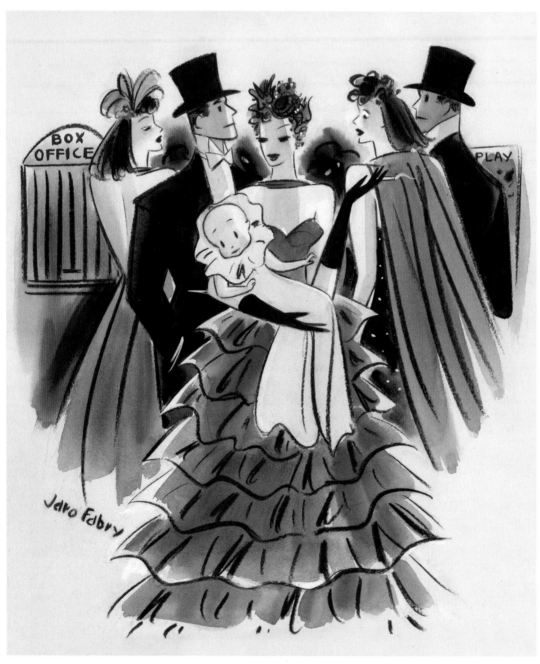

Above: unpublished *Collier's* cover for December 10, 1938, conte crayon and watercolor on paper. **Opposite page:** unknown magazine cover, watercolor on board.

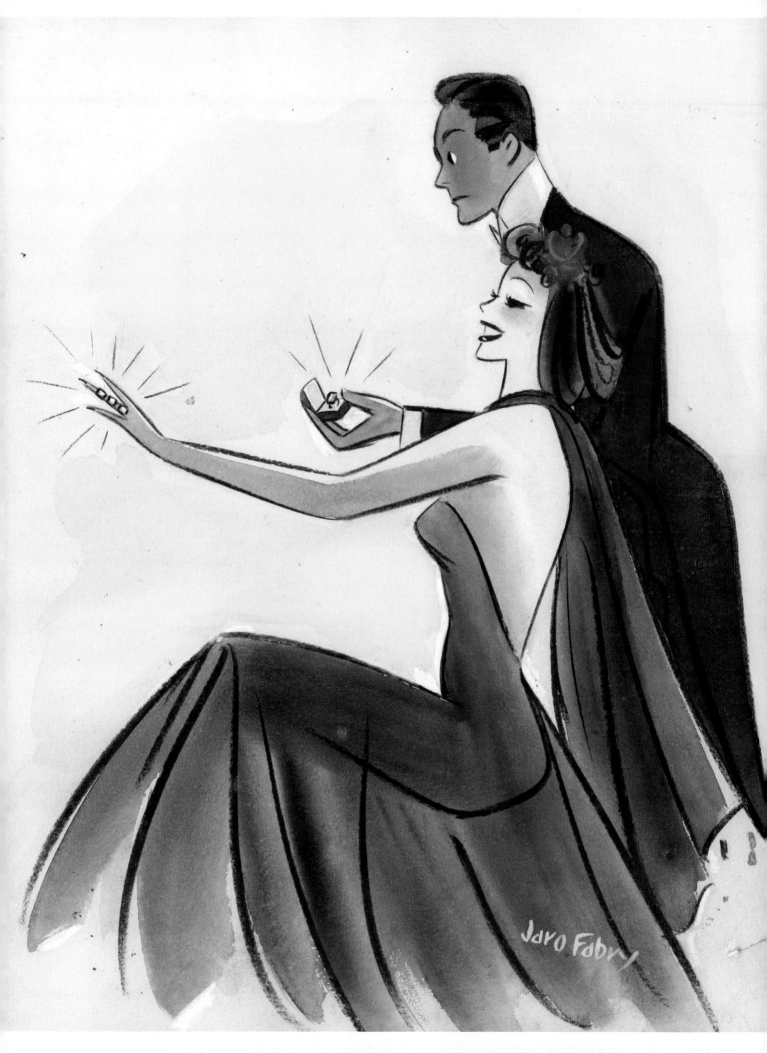

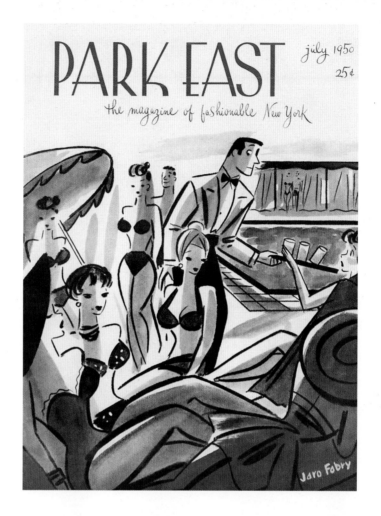

Above: *Park East* cover,
July, 1950. Below: *Kirkeby
Hotels Magazine* cover,
November, 1947. Opposite
page: *Havard Yale Regatta*
cover, June 25, 1937.

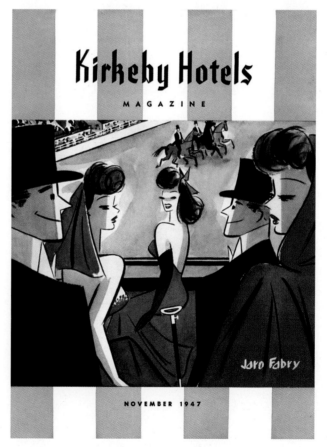

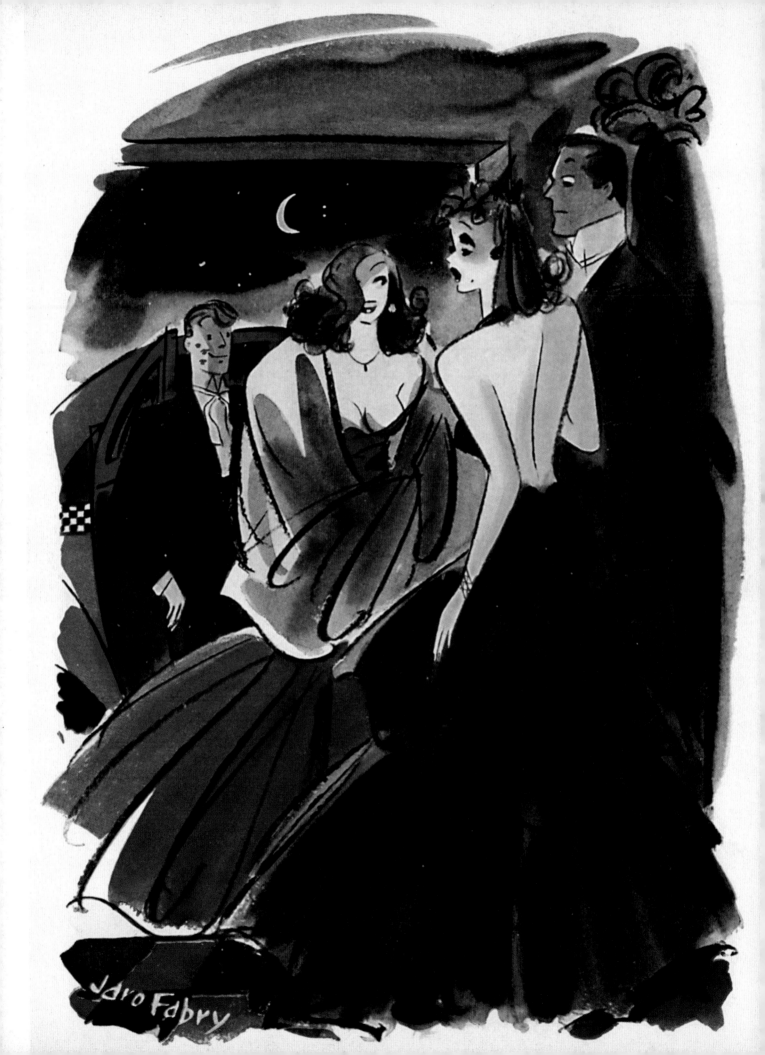

chapter two
cartoons

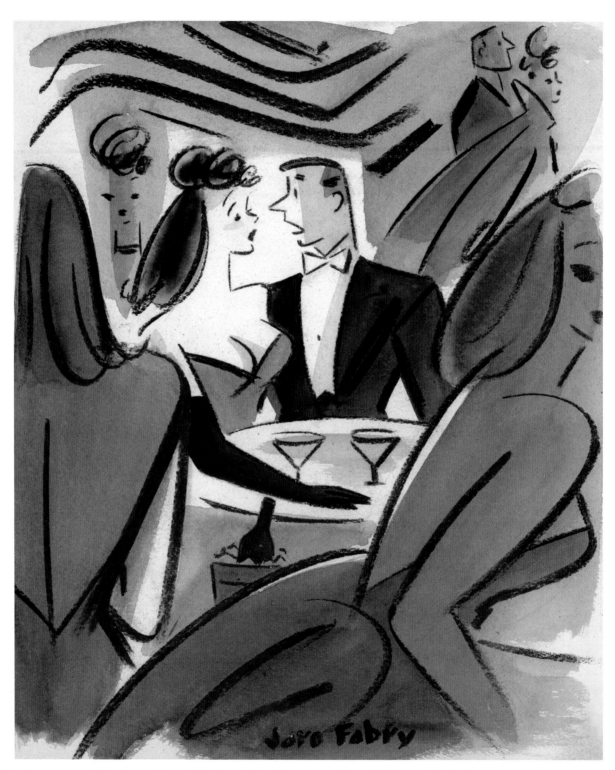

Previous pages: *Esquire* cartoon, "We thought we'd never get here." Above: *Collier's* cartoon, conte crayon and watercolor on paper. Opposite page: *Esquire* cartoon, "Now, what ever gave them the idea I was working!"

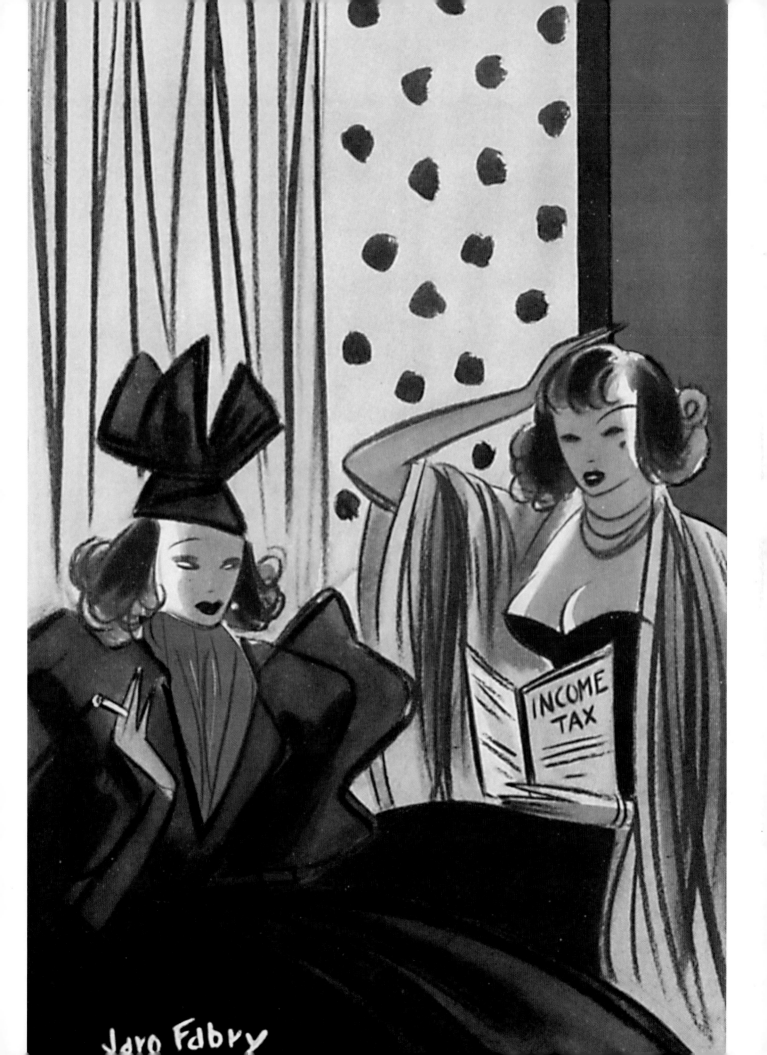

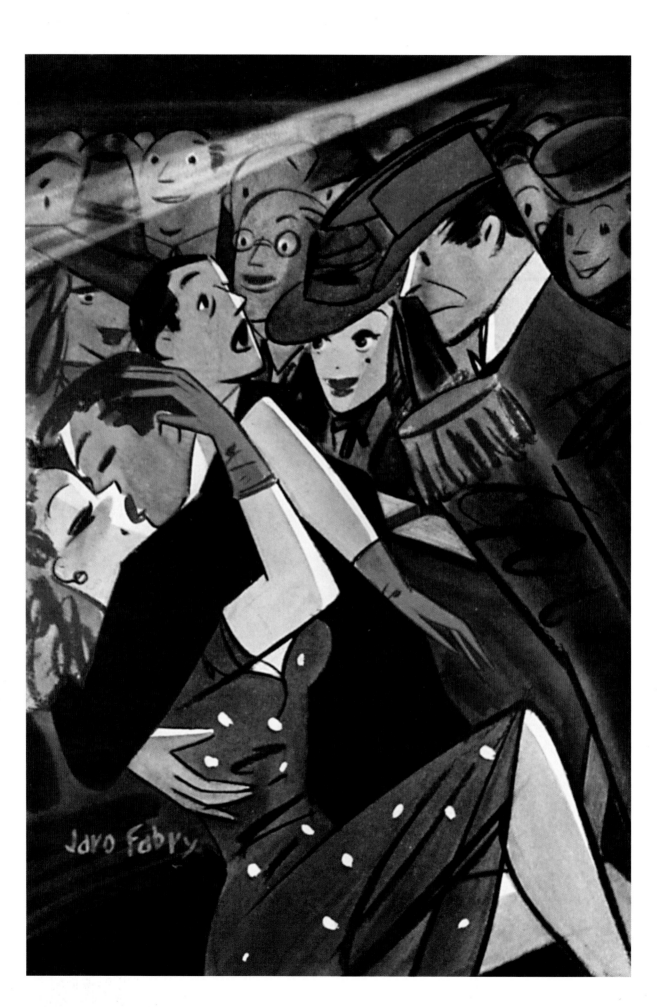

Above: *Collier's* cartoon, conte crayon and watercolor on paper. Opposite page: *Esquire* cartoon, "Aw, leave 'em alone! It's a much better ending than the picture had."

"I TOLD HIM HE'D HAVE TO MAKE UP HIS MIND, ONCE AND FOR ALL - BETWEEN ME AND SAVING HIS MONEY!"

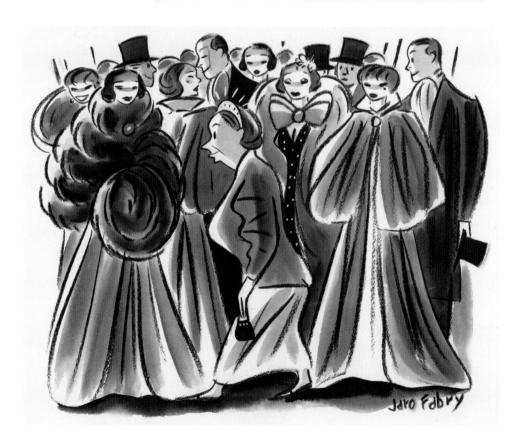

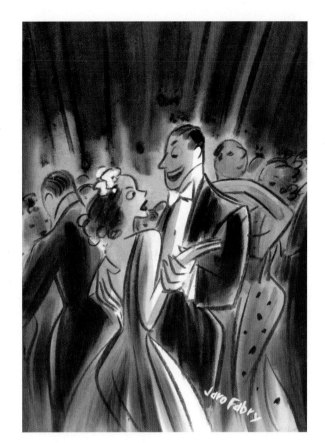

Top: unknown magazine cartoon, conte crayon and watercolor on paper. Below: *Collier's* cartoon, conte crayon and watercolor on paper. Opposite page top: *Collier's* cartoon, January 20, 1950, conte crayon and watercolor on paper. Bottom: unknown magazine cartoon, conte crayon and watercolor on paper.

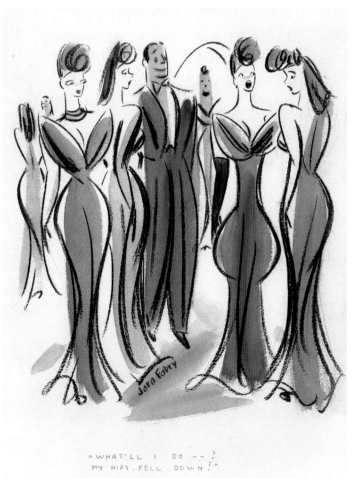

"WHAT'LL I DO --?
MY HIPS FELL DOWN!"

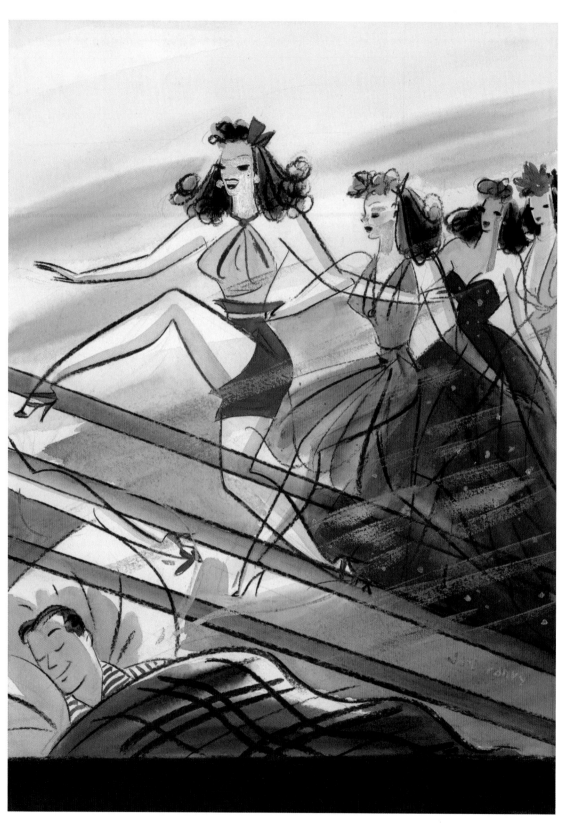

Above: "Man Counting Women in his Sleep," unpublished cartoon, watercolor on paper. **Opposite page:** "Winning Stroke," *Collier's* story cartoon, June 25, 1938, conte crayon and watercolor on paper.

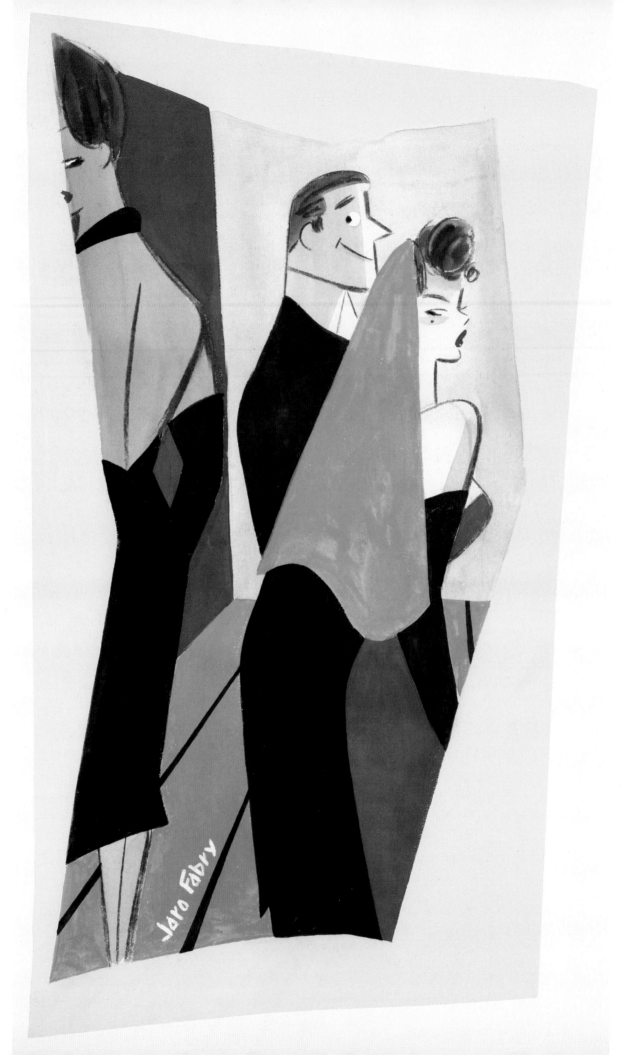

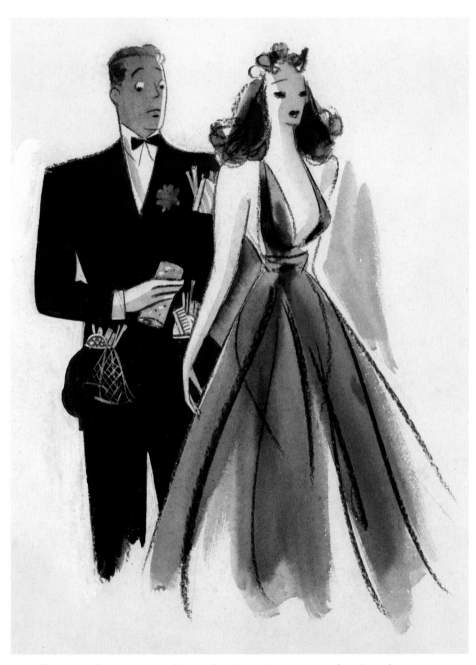

Above: unknown magazine cartoon, conte crayon and watercolor on paper. **Opposite page:** unknown magazine cartoon, watercolor on paper.

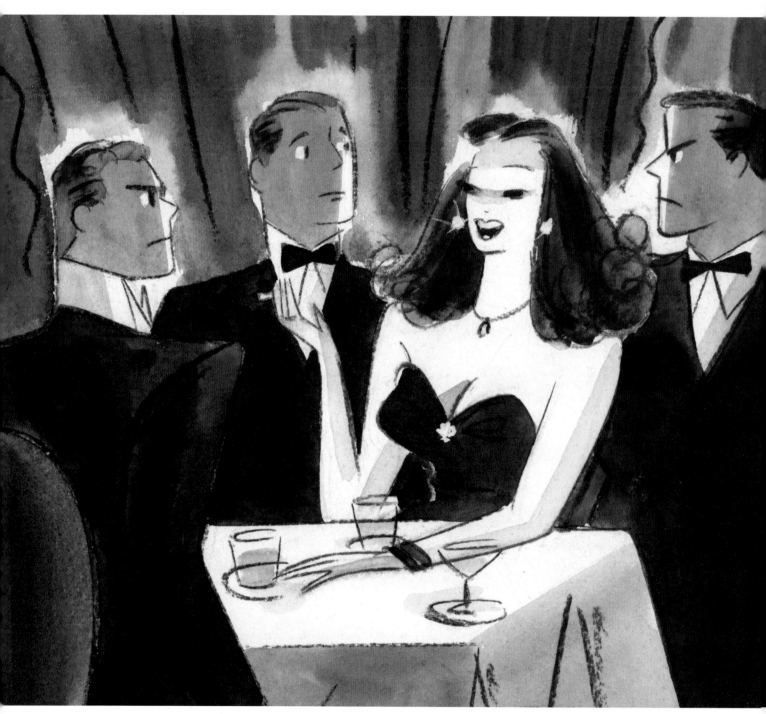

Above: unknown magazine cartoon, conte crayon and watercolor on paper. Opposite page: *Collier's* cartoon, May 28, 1949, conte crayon and watercolor on paper.

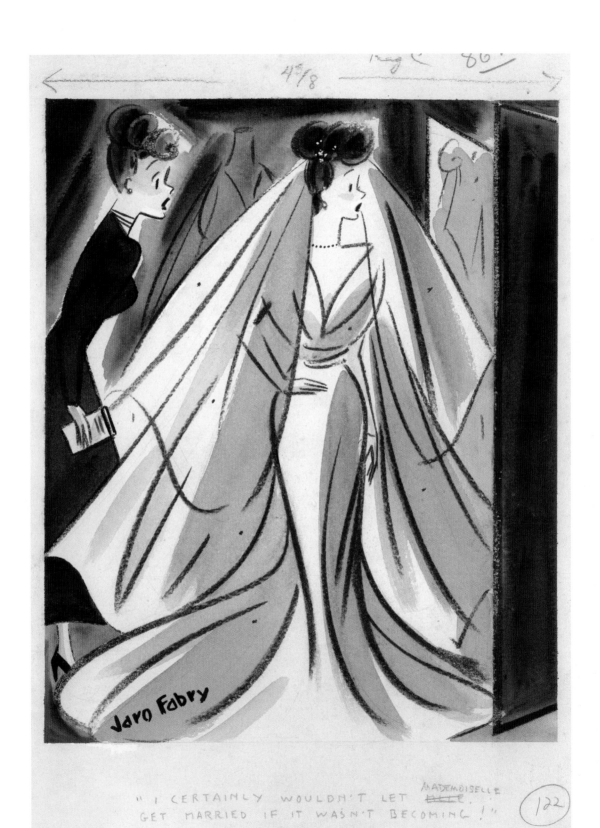

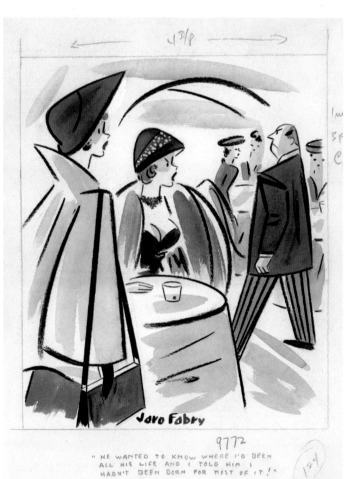

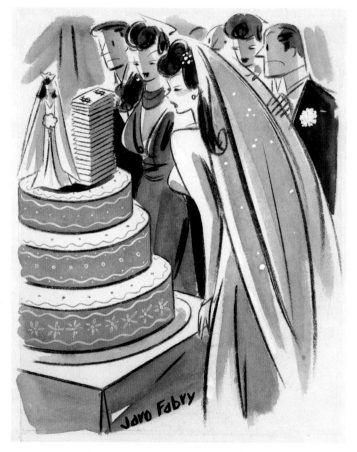

Left: *Collier's* cartoon, July 29, 1950, conte crayon and watercolor on paper. Right: *Collier's* cartoon, conte crayon and watercolor on paper. Opposite page: *Esquire* cartoon, conte crayon and watercolor on paper, "We won't be disturbed in here—this is my husband's den."

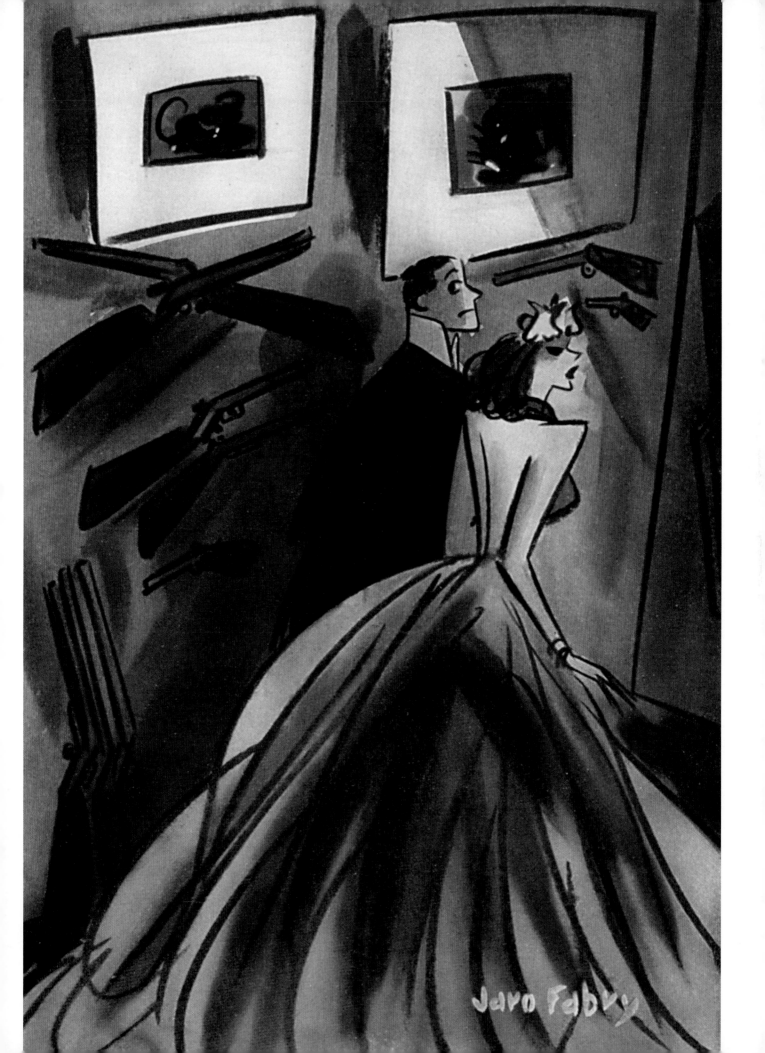

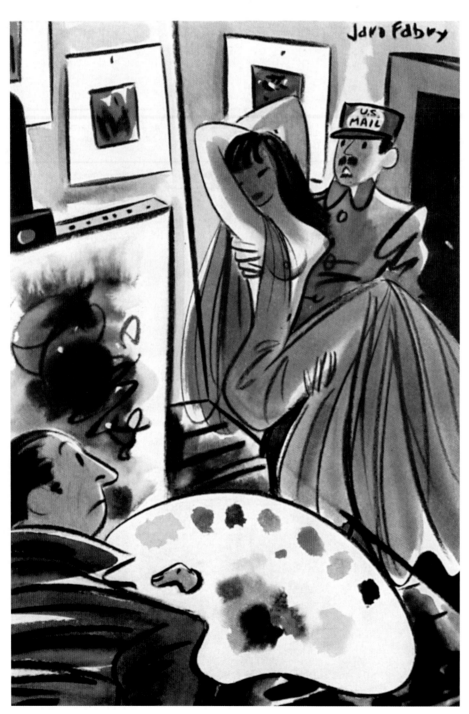

Above: *Esquire* cartoon, "Here's your art school correspondence course—lesson number seven." **Opposite page:** *Collier's* cartoon, conte crayon and watercolor on paper, "When I said 'let's make it a foursome' Michael—I had a somewhat different idea!"

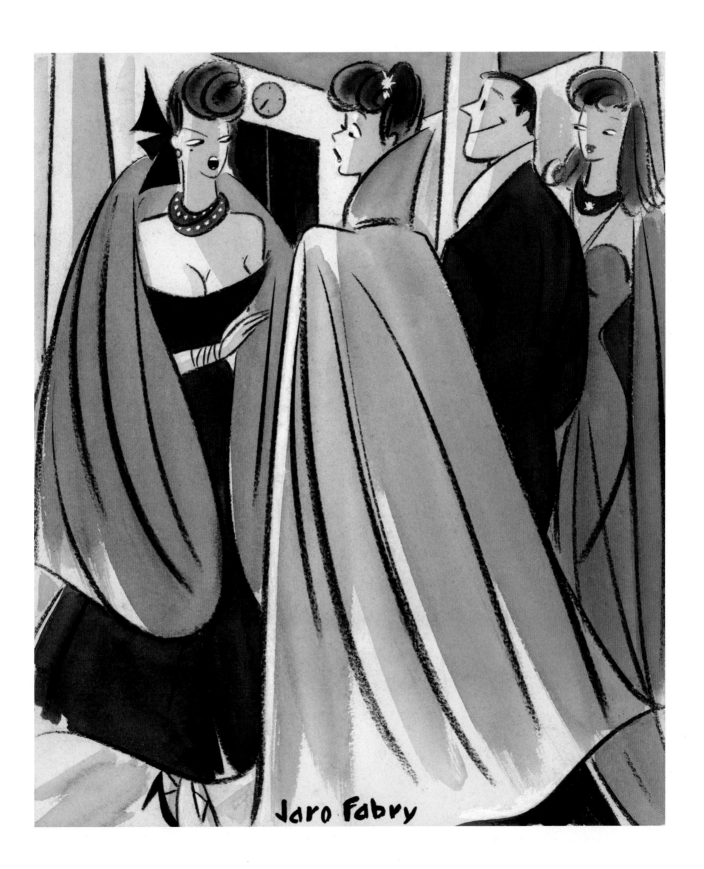

Jaro Fabry

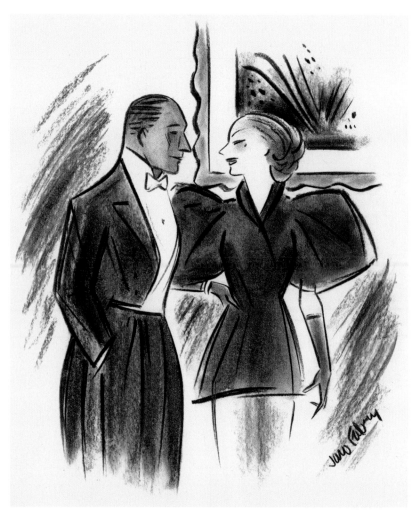

Above: unknown magazine cartoon. Below: *Collier's* cartoon, conte crayon and watercolor on paper. Opposite page: *Esquire* cartoon.

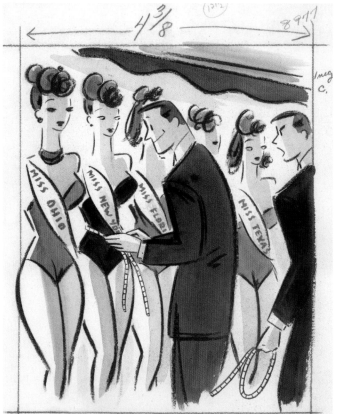

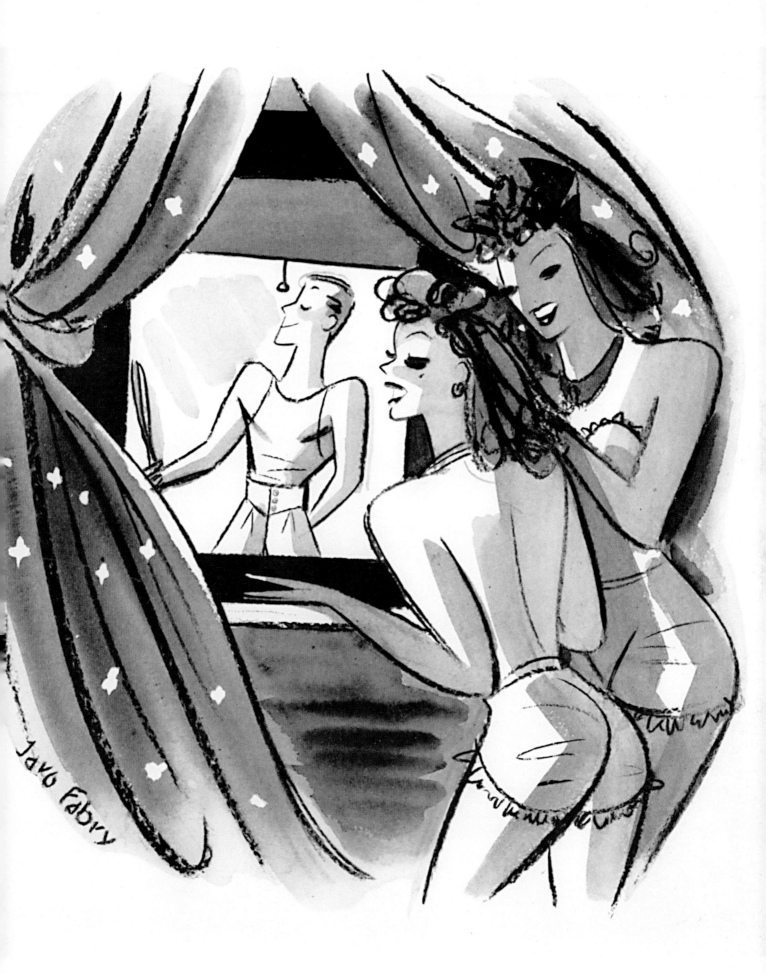

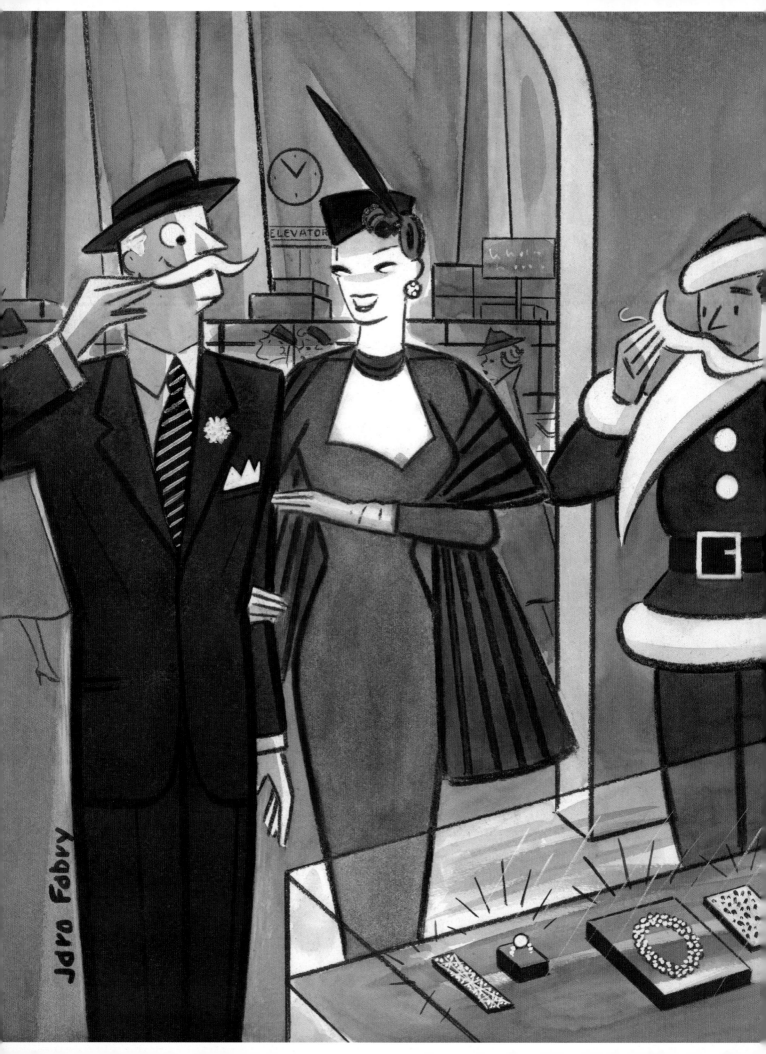

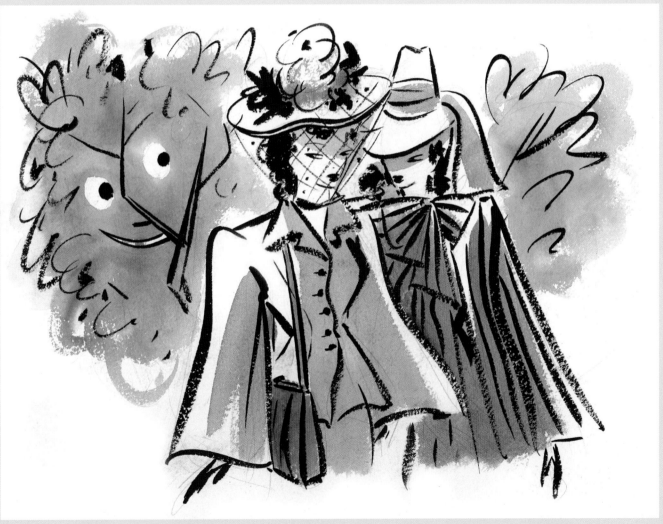

Above: unpublished magazine cartoon, conte crayon and watercolor on paper. Opposite page: unknown magazine cartoon, conte crayon and watercolor on illustration board.

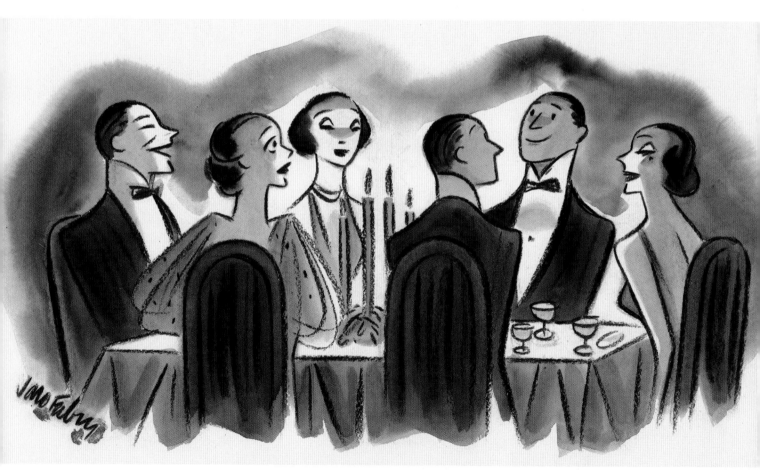

Above: unknown magazine cartoon, conte crayon and watercolor on paper.
Opposite page: unknown magazine cartoon, conte crayon and watercolor on paper, "Is that the only expression you know... 'Boy is she built'?"

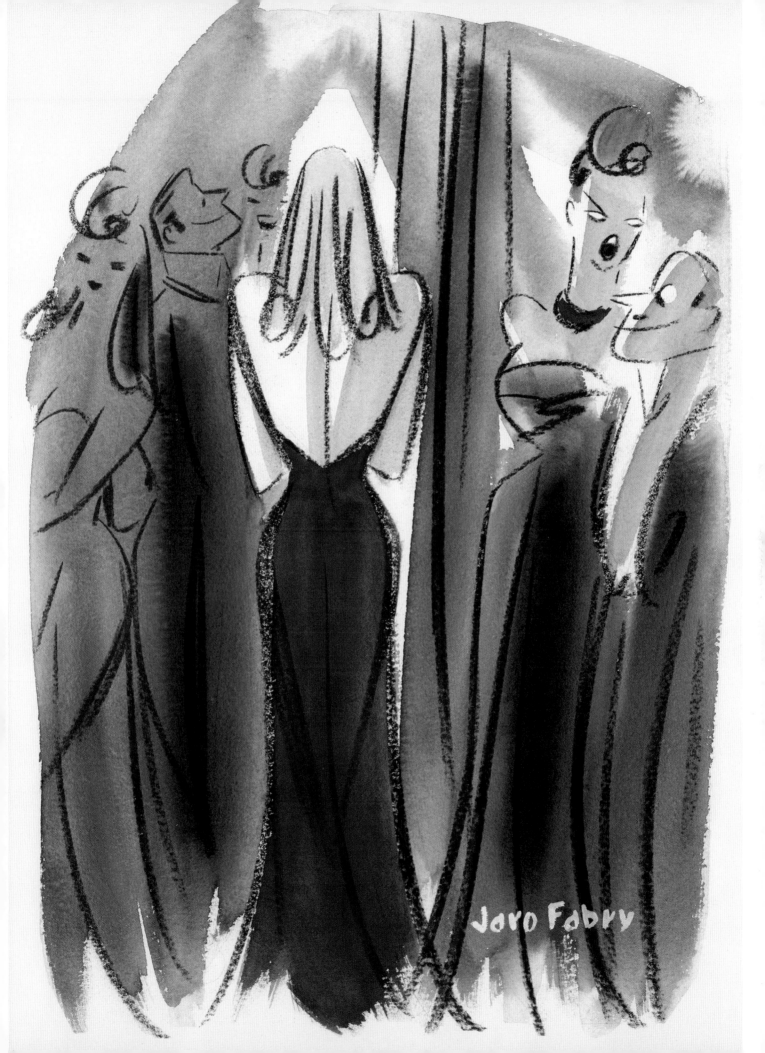

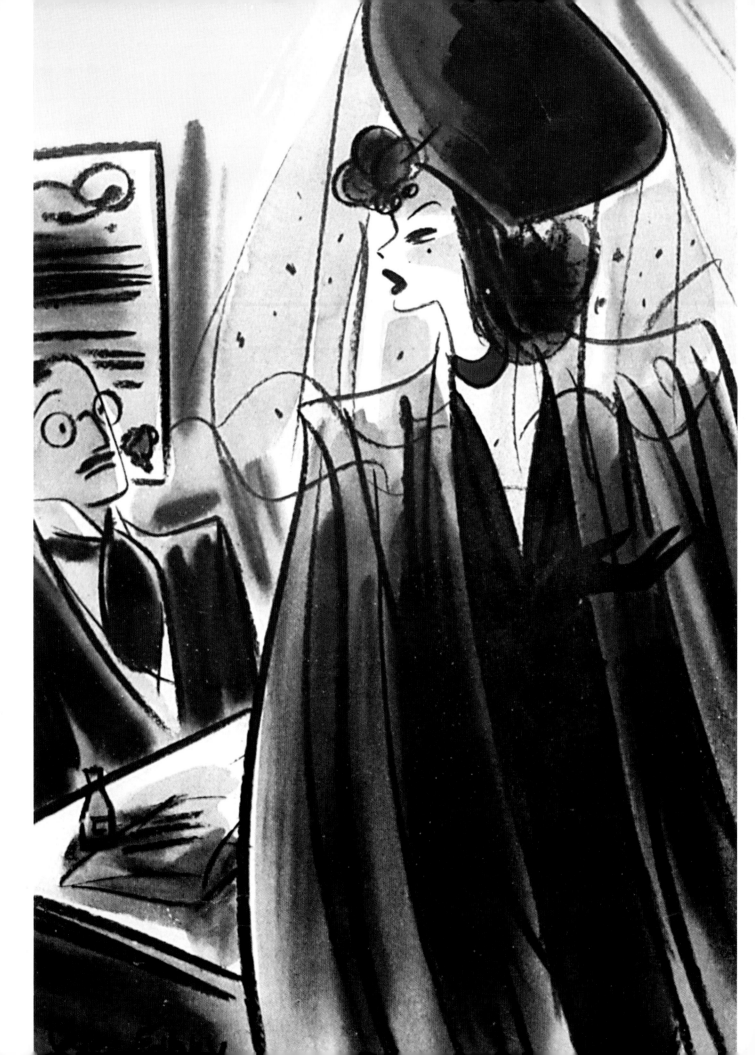

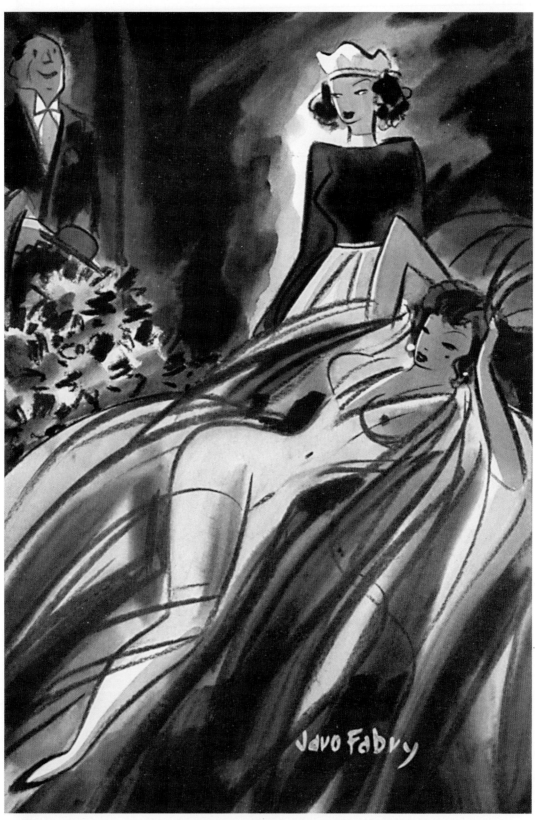

Above: *Esquire* cartoon, "I know your wages are small, Marie—but after all, you're learn-ing." **Opposite page:** *Esquire* cartoon, "You mean the stork is going to bring me a baby?"

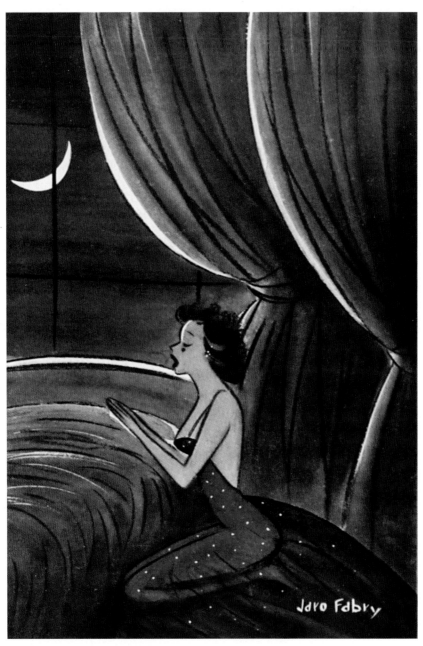

Above: *Esquire* cartoon, "I got the diamond necklace—now how about the sables?" Opposite page: unknown magazine cartoon, conte crayon and watercolor on paper.

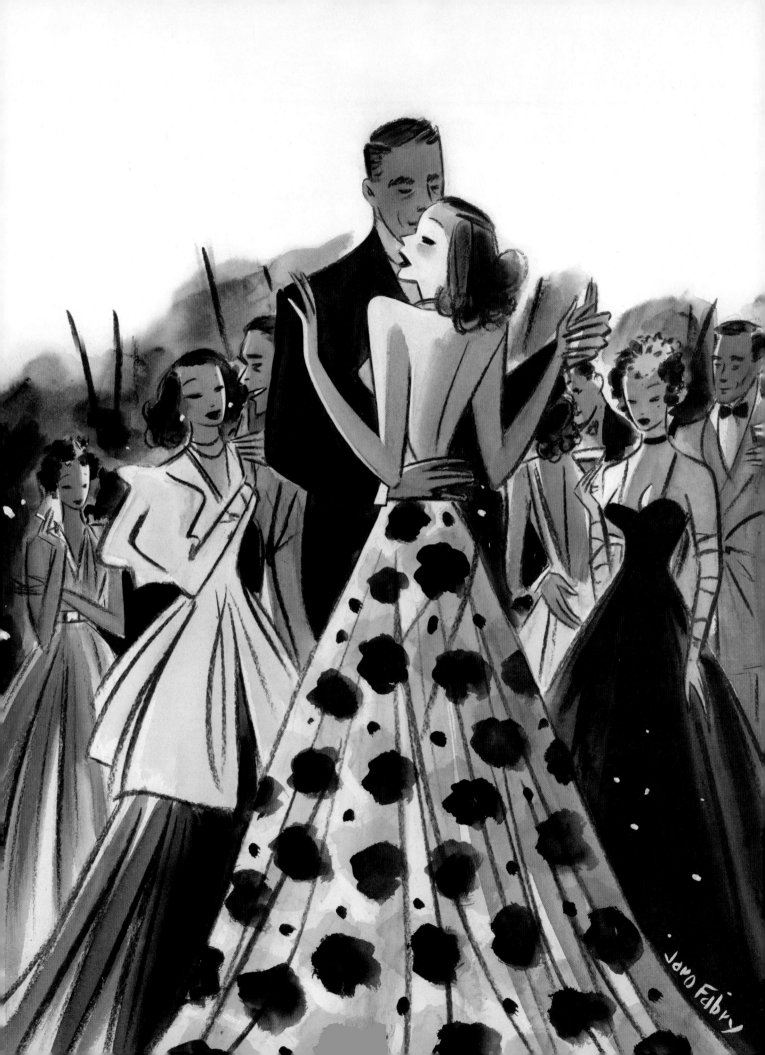

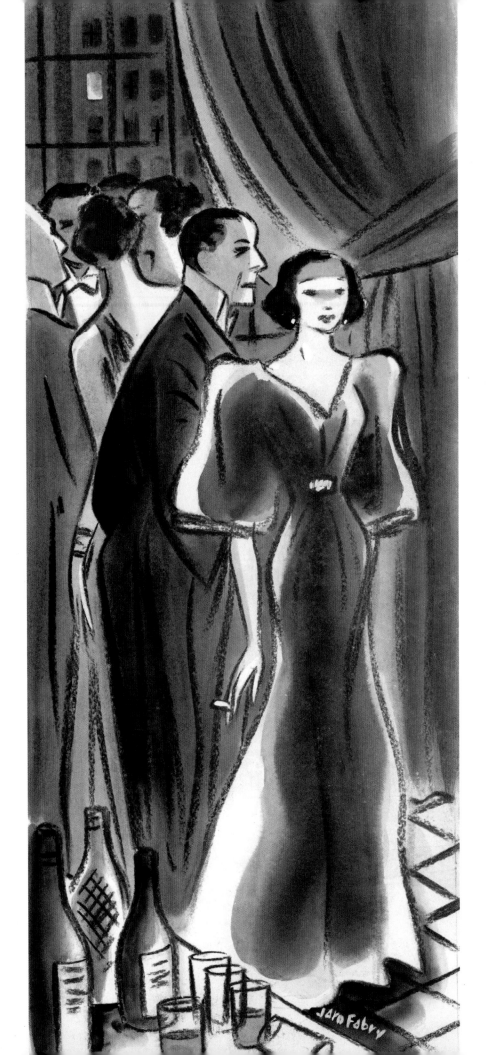

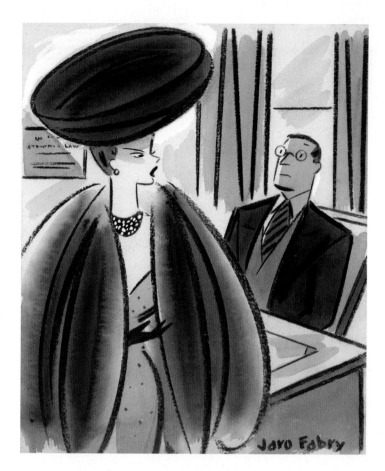

Top: *Collier's* cartoon, conte crayon and watercolor on paper, "He's got everything a woman could ask for—and I intend to ask for it!" Below: unknown magazine cartoon, conte crayon and watercolor on paper. Opposite page: unknown magazine cartoon, conte crayon and watercolor on paper.

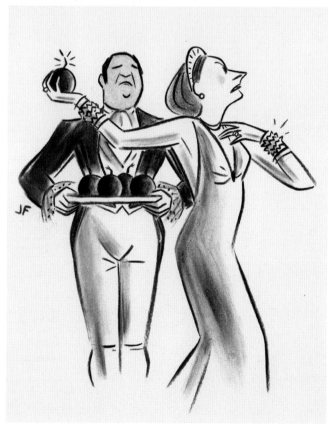

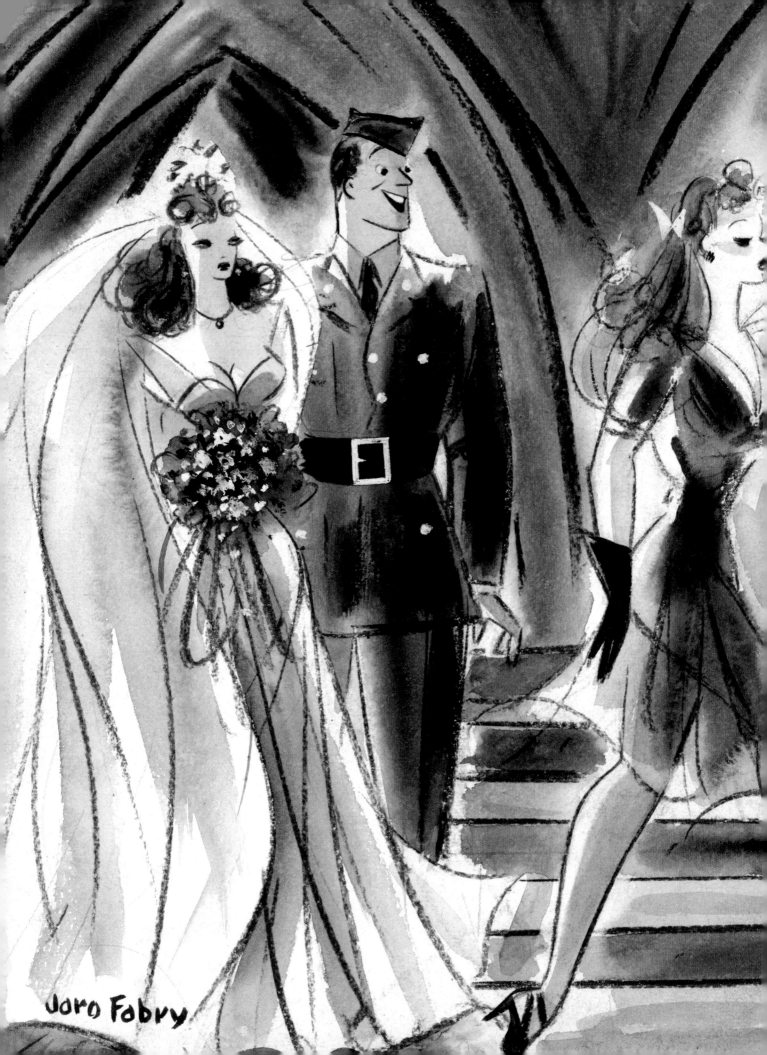

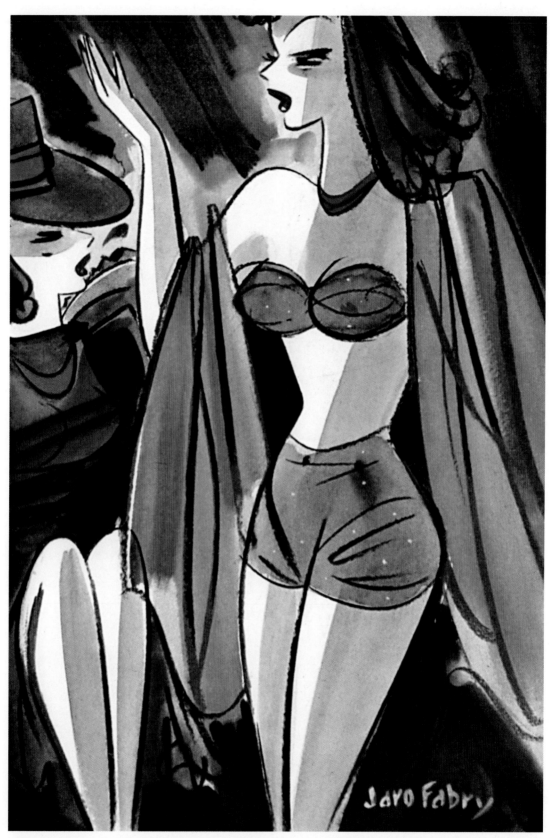

Above: *Esquire* cartoon, "He's paying me fifty thousand dollars to get back his letters, but I'm retaining the movie rights." **Opposite page:** *Wright Take Off* magazine cartoon, July 19, 1943 (first "Fabry Girl" for the publication), conte crayon and watercolor on paper, "Wow!"

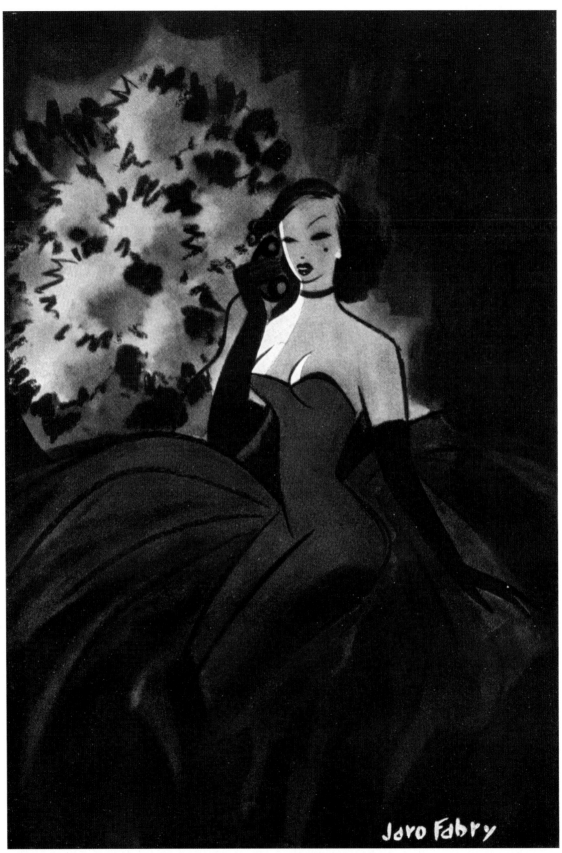

Above: *Esquire* cartoon, "I don't think I'll go—my husband always stays sober and makes a fool of himself!" Opposite page: *Saturday Home Magazine* cartoon, conte crayon and watercolor on paper.

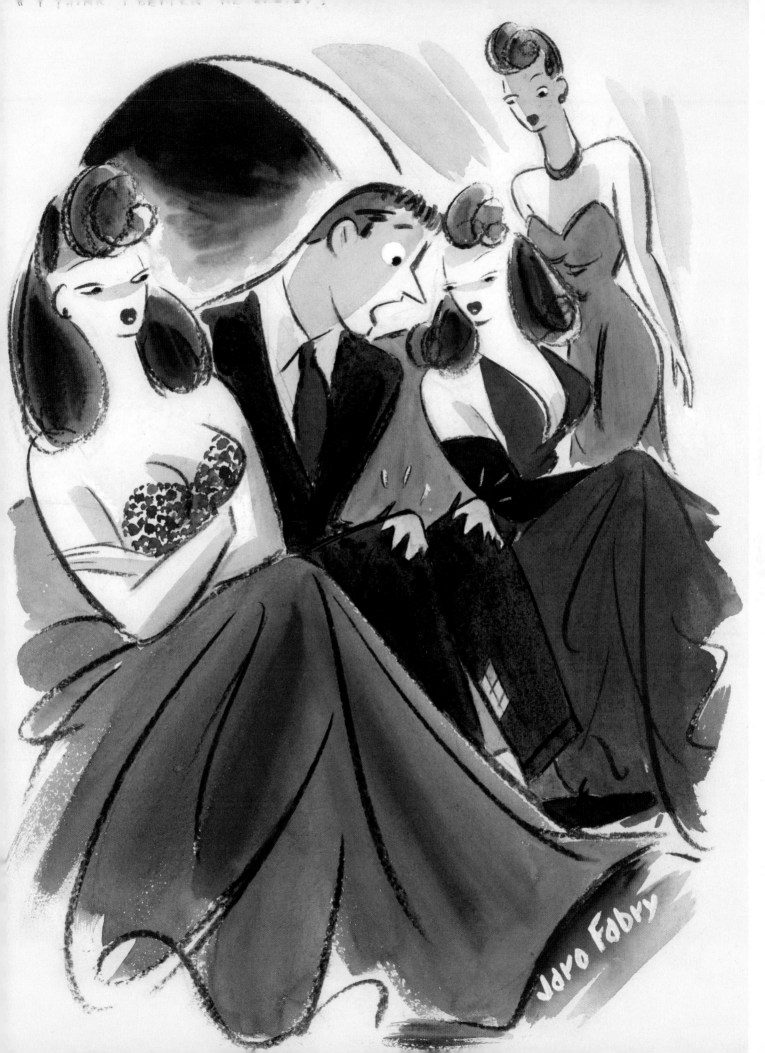

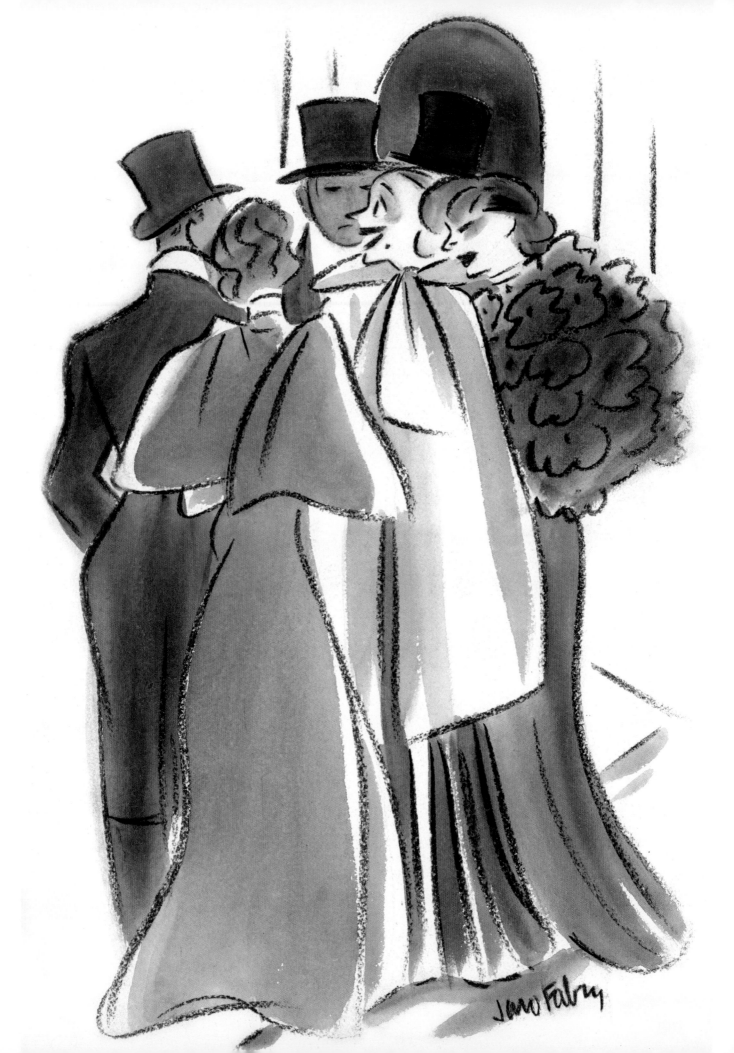

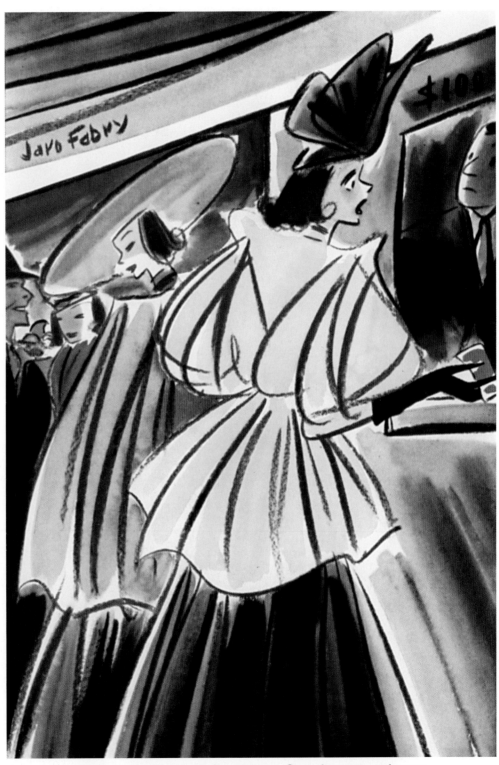

Above: unknown magazine cartoon. Opposite page: unknown magazine cartoon, conte crayon and watercolor on paper.

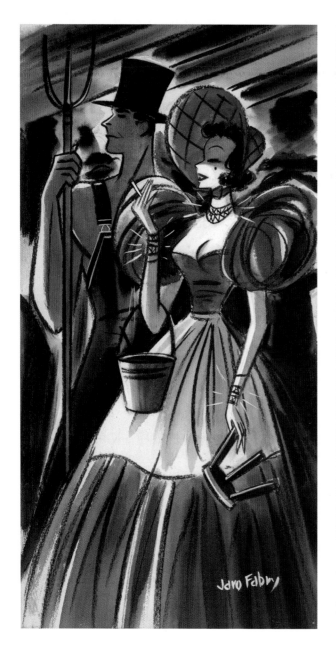

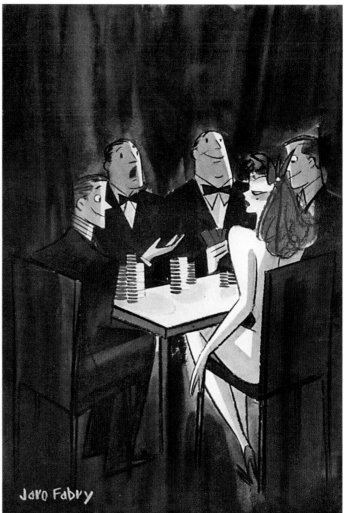

Left: unknown magazine cartoon, conte crayon and water-color on paper. Right: unknown magazine cartoon, "You might at least let us give you carfare home." Opposite page: *Esquire* cartoon, "This is awful nice of you, Miss Terrel—I wrote momma I wasn't homesick no more."

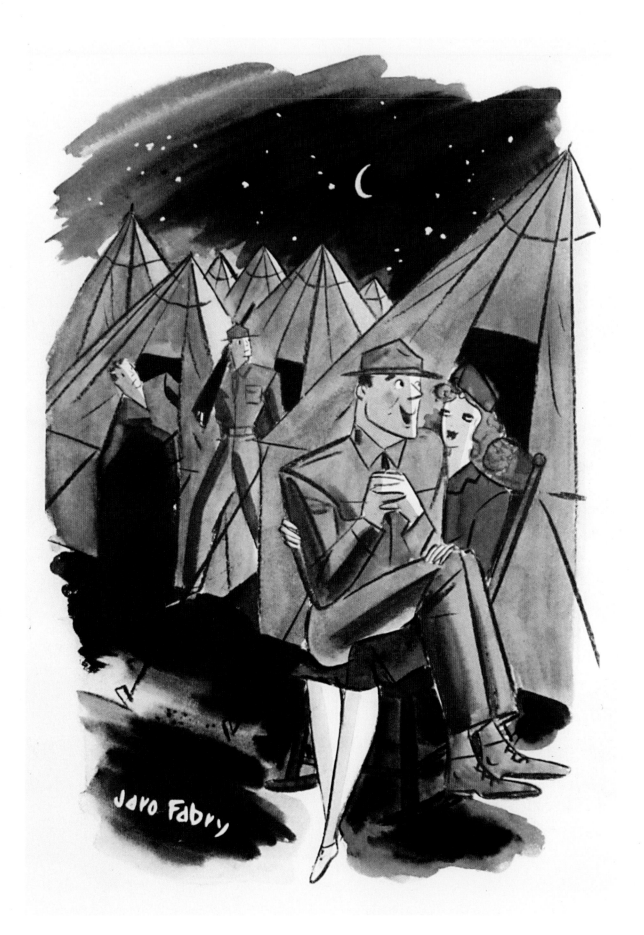

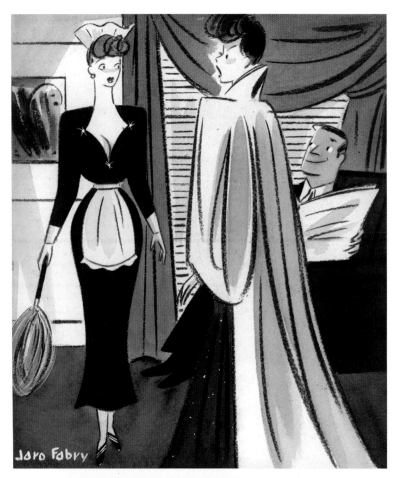

Top: unknown magazine cartoon, conte crayon and watercolor on paper, "I realize you have a right to the new look Hortense—but after hours please!" Bottom: unknown magazine cartoon, conte crayon and watercolor on paper. Opposite page: top: unknown magazine cartoon, conte crayon and watercolor on paper. Bottom: *Collier's* cartoon, conte crayon and watercolor on paper.

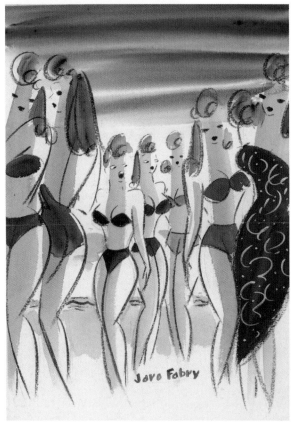

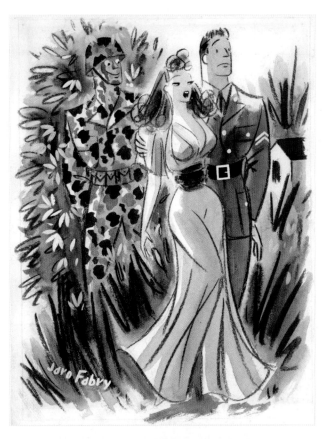

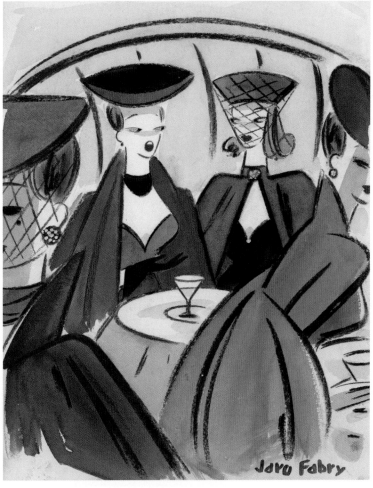

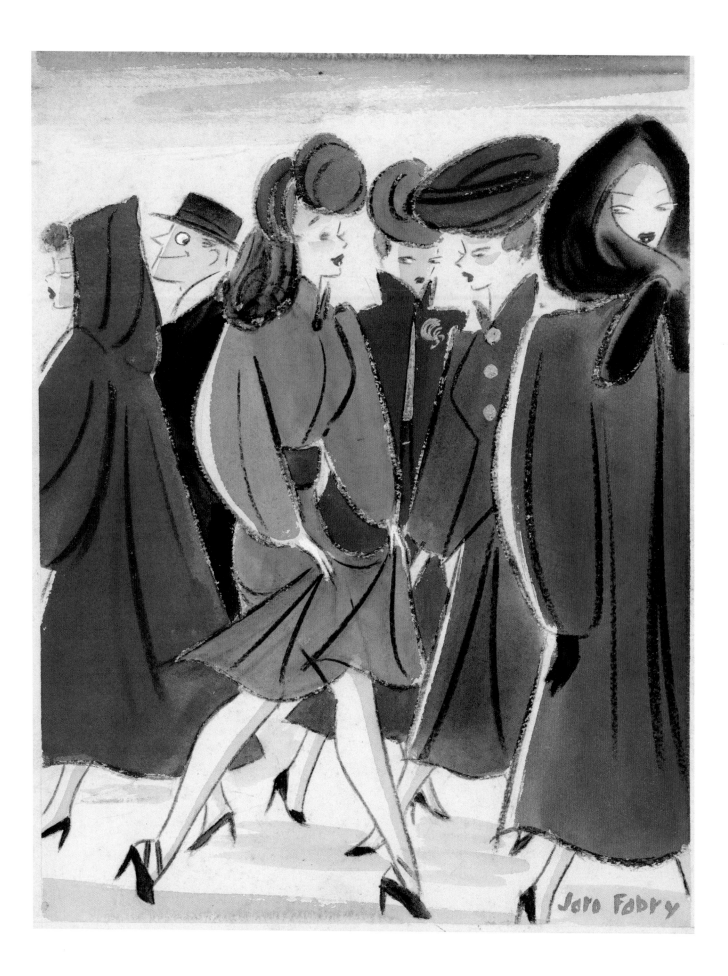

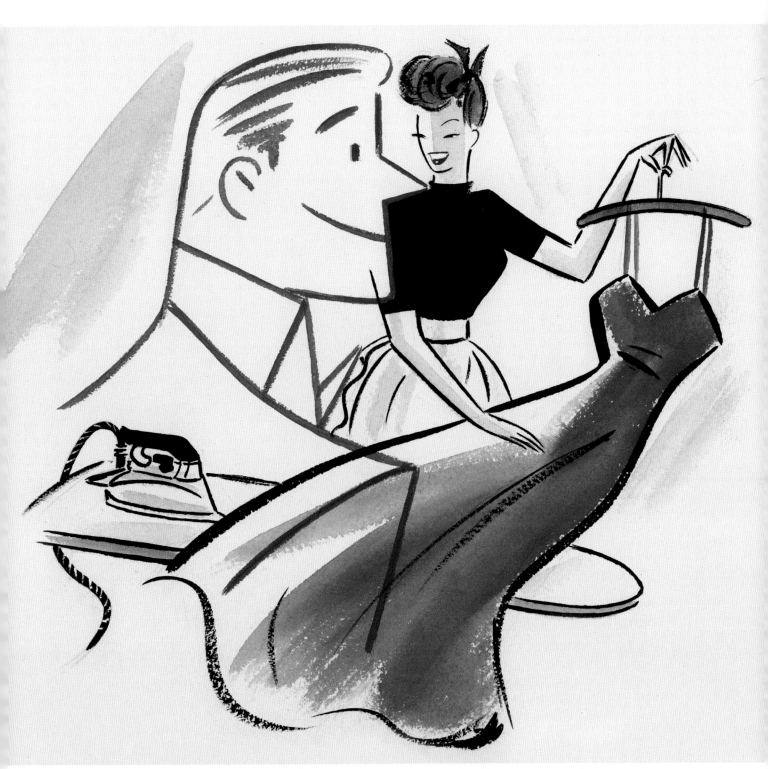

Above and opposite page: two unknown magazine cartoons, conte crayon and watercolor on paper.

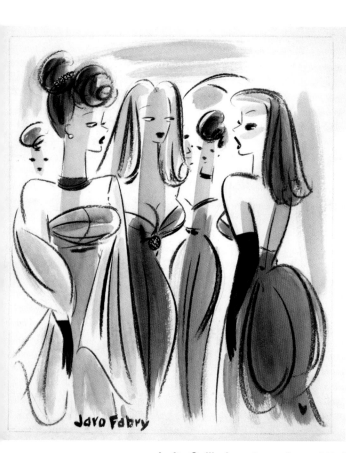

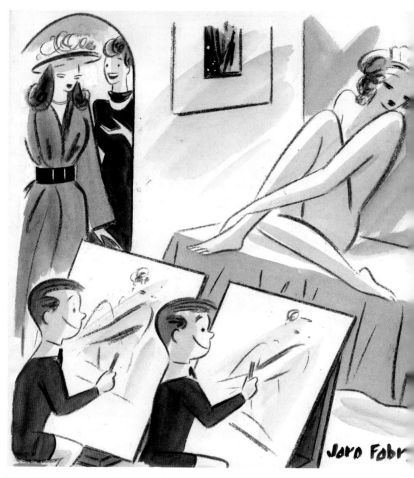

Left: *Collier's* cartoon, August 7, 1948, conte crayon and watercolor on paper. Right: unknown magazine cartoon, conte crayon and watercolor on paper. Opposite page: unknown magazine cartoon, conte crayon and watercolor on paper.

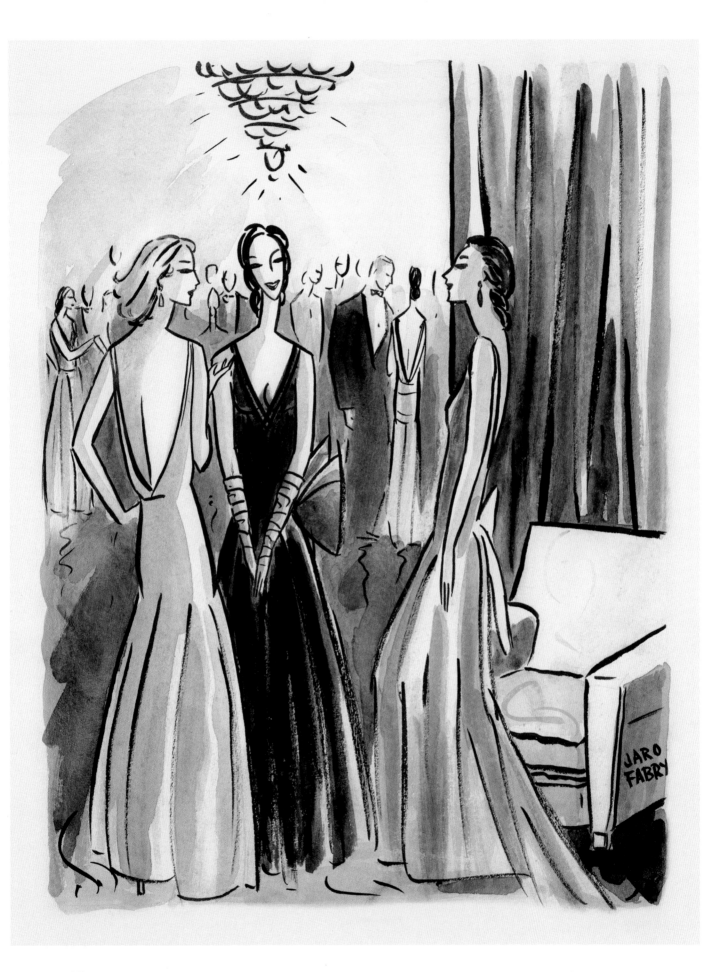

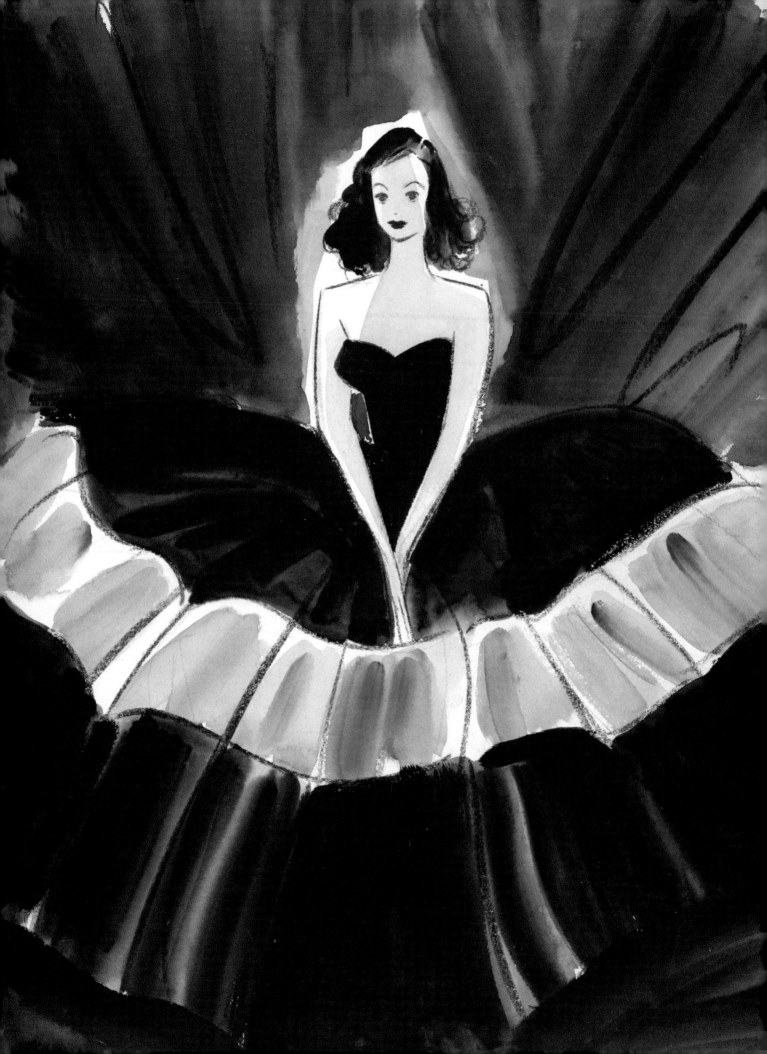

chapter three
illustration

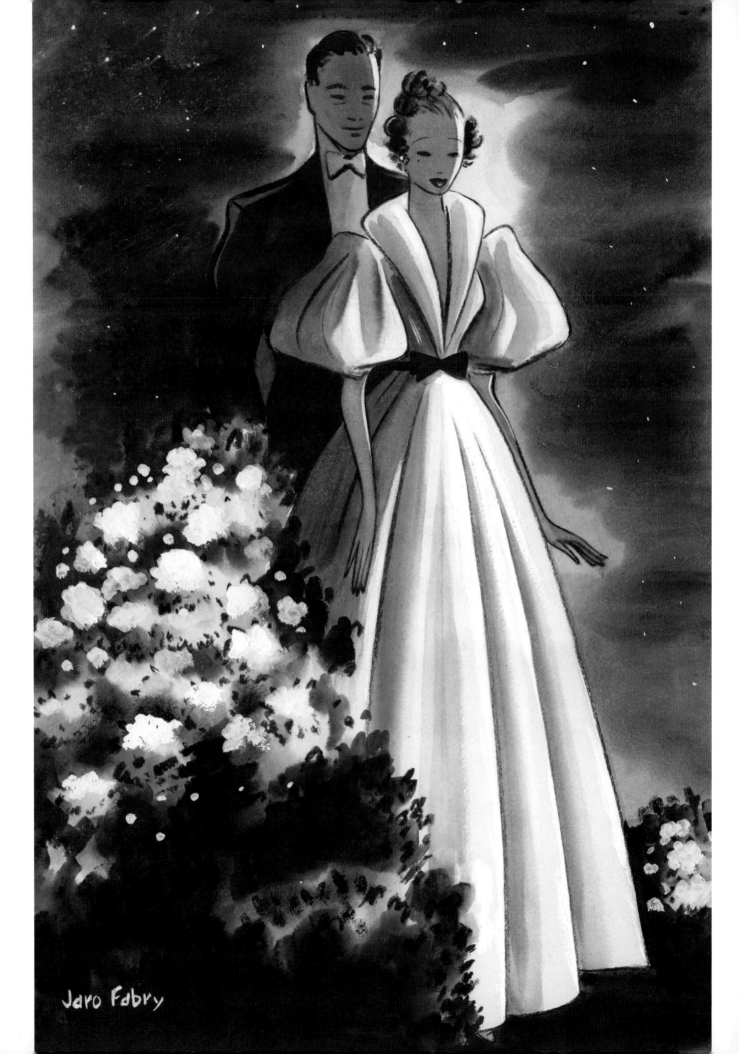

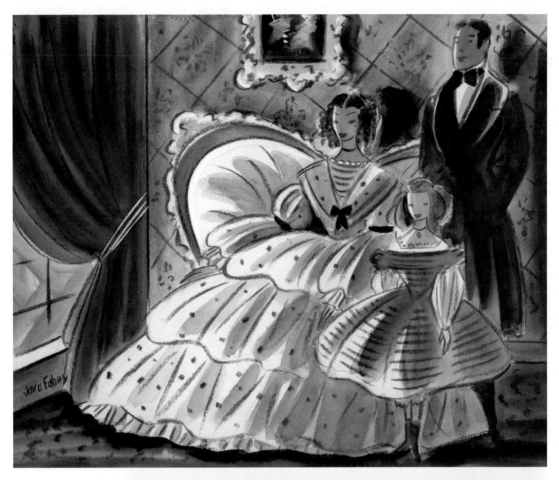

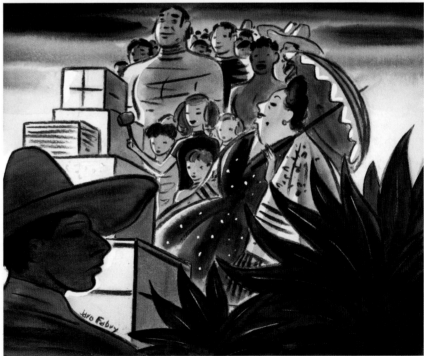

Previous pages: unpublished painting, conte crayon and watercolor on paper. Top and bottom: concept paintings for a 1930s unrealized movie production of Richard Hughes' novel *High Wind in Jamaica*, both conte crayon and watercolor on paper. Opposite page: unknown magazine illustration, conte crayon and watercolor on paper.

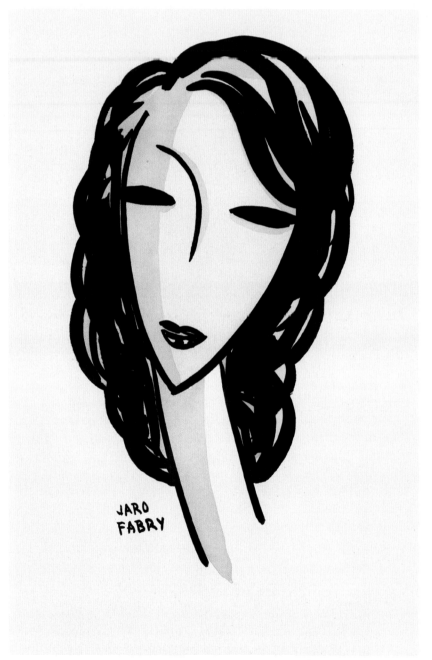

**Above: Portrait of a Woman, ink and ink wash on board.
Opposite page: unknown magazine illustration, Woman in
a Green Hat, conte crayon and watercolor on paper.**

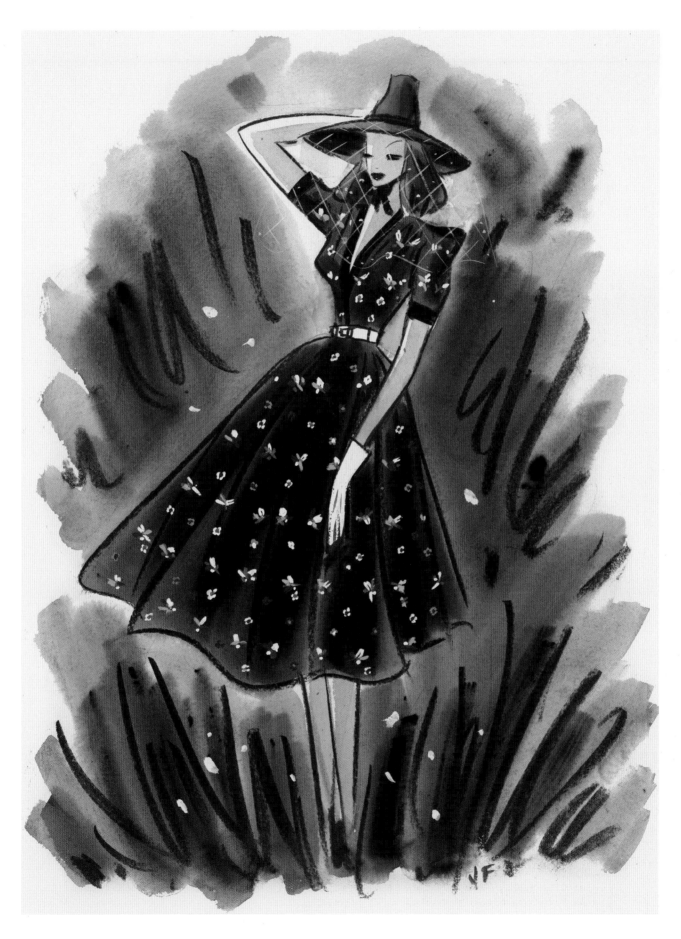

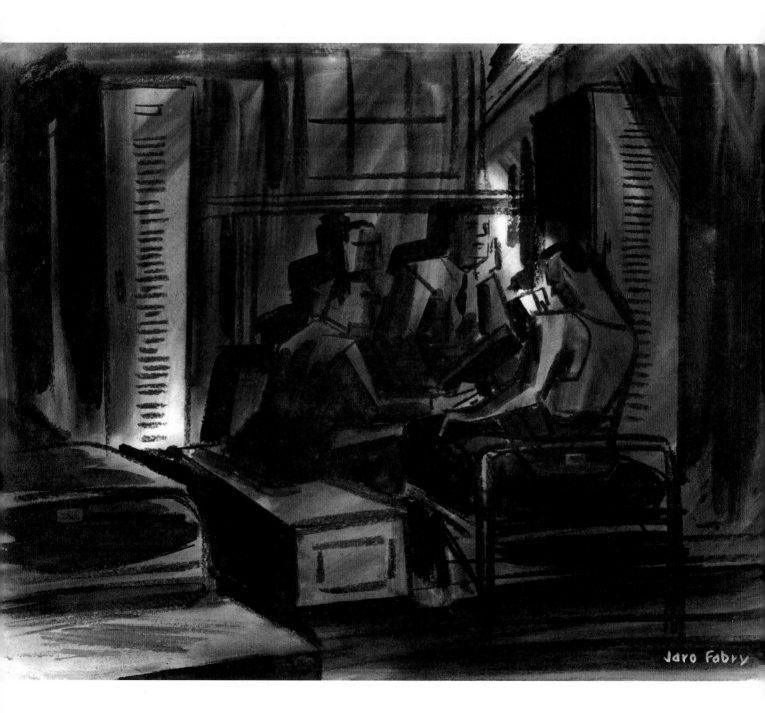

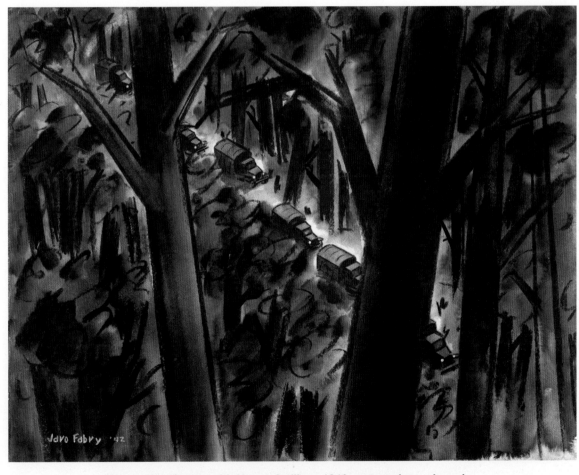

Above: War Scene with Heavy Artillery, 1943, watercolor on board.
Opposite page: Army Scene, 1942, watercolor on paper.

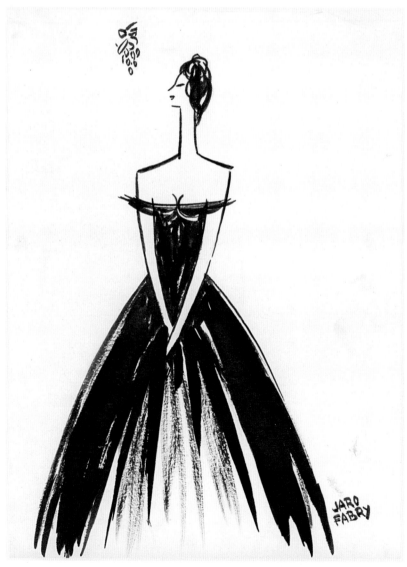

Above: Christmas card illustration, ink on board. Opposite page: Nude, conte crayon and watercolor on paper.

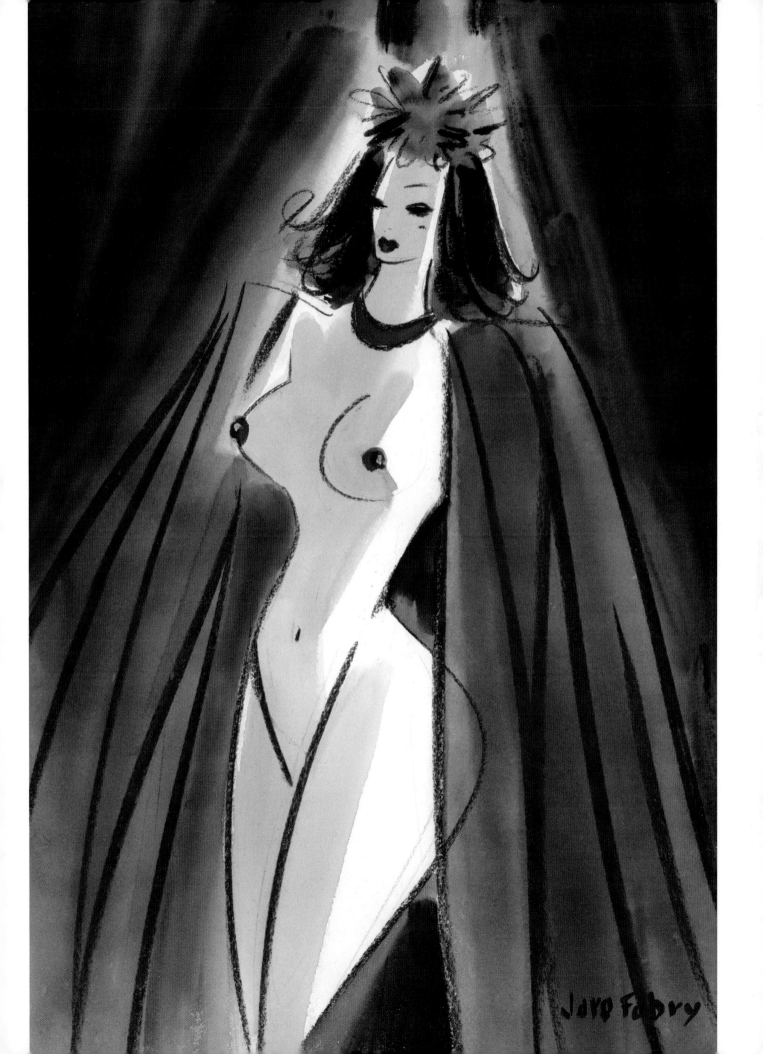

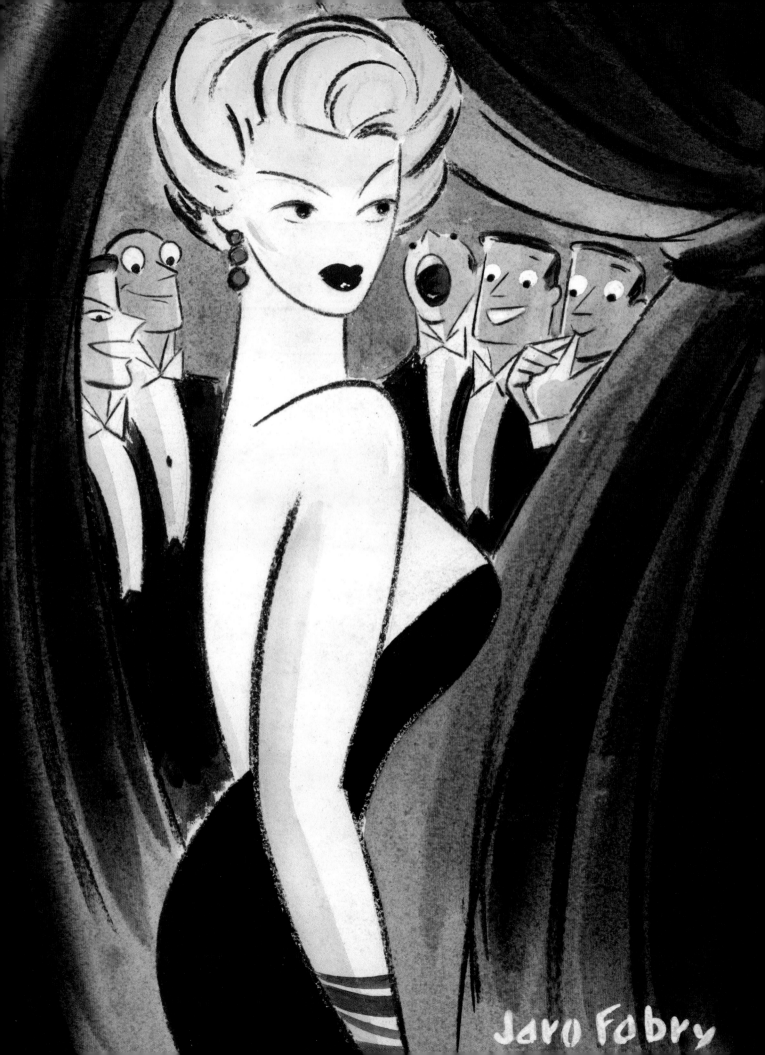

chapter four
hollywood and broadway

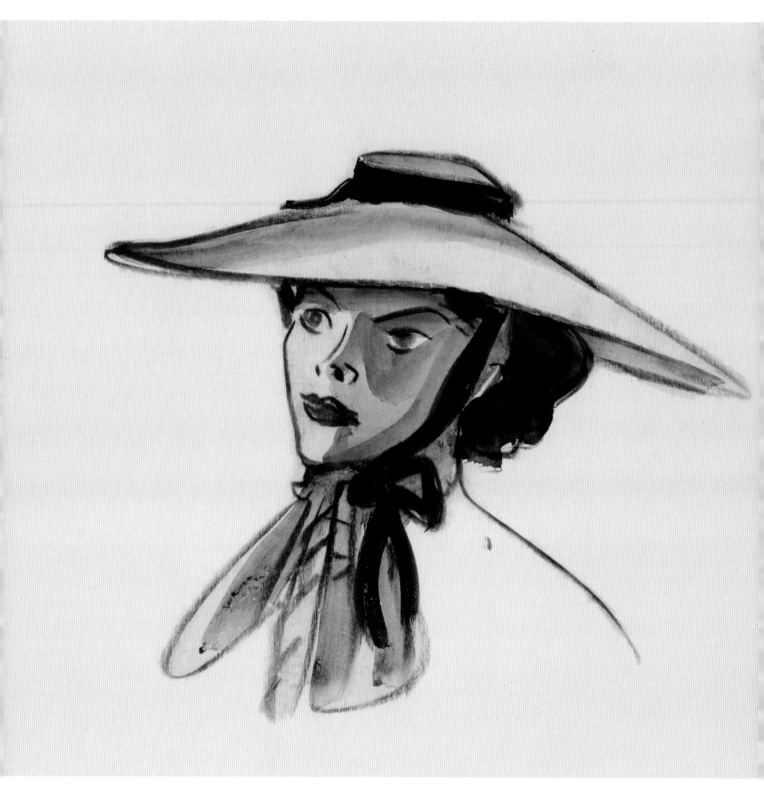

Previous pages: Lana Turner, conte crayon
and watercolor on paper.

Above: Katherine Hepburn, watercolor on paper. Opposite
page: Alice Faye, conte crayon and watercolor on paper.

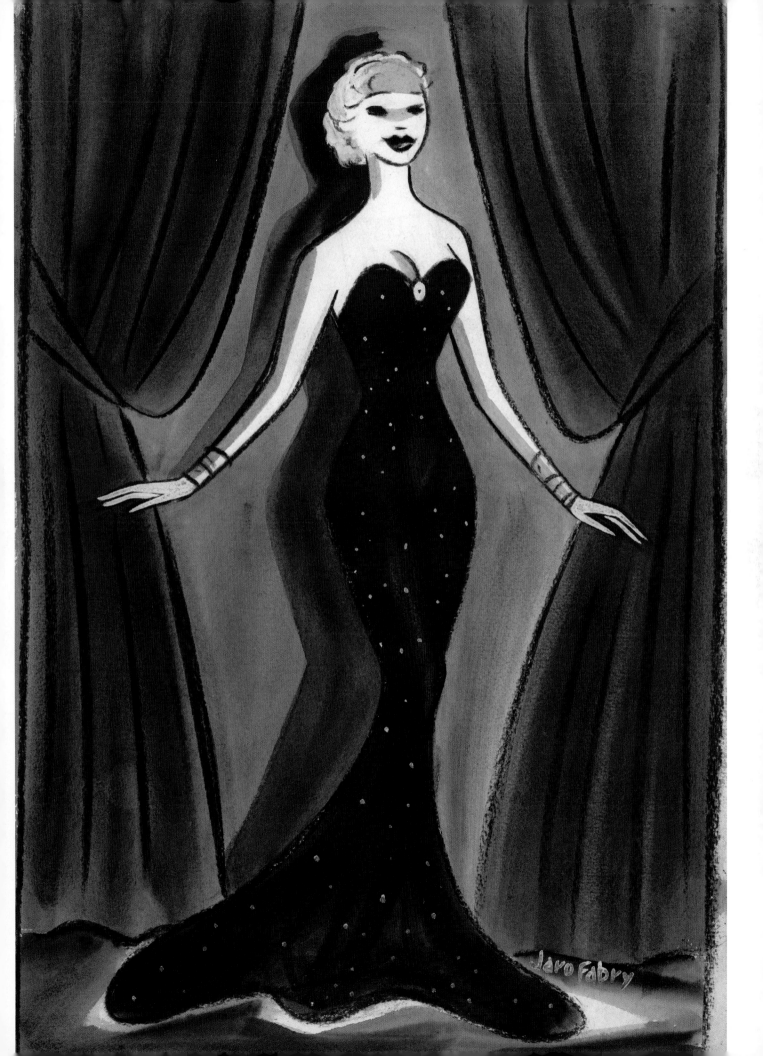

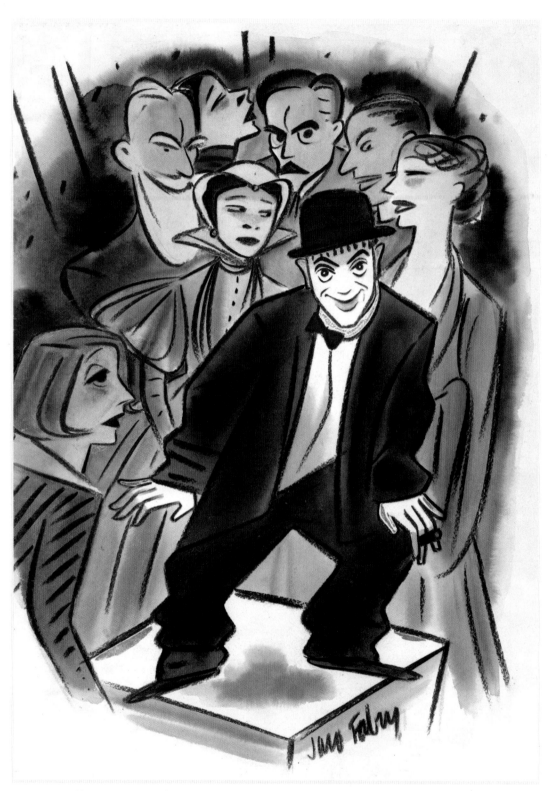

Above: Theater Guild illustration, conte crayon and watercolor on paper.
Opposite page: The Producer, conte crayon and water color on paper.

Overleaf: study for A Party at the El Morocco, watercolor on paper.

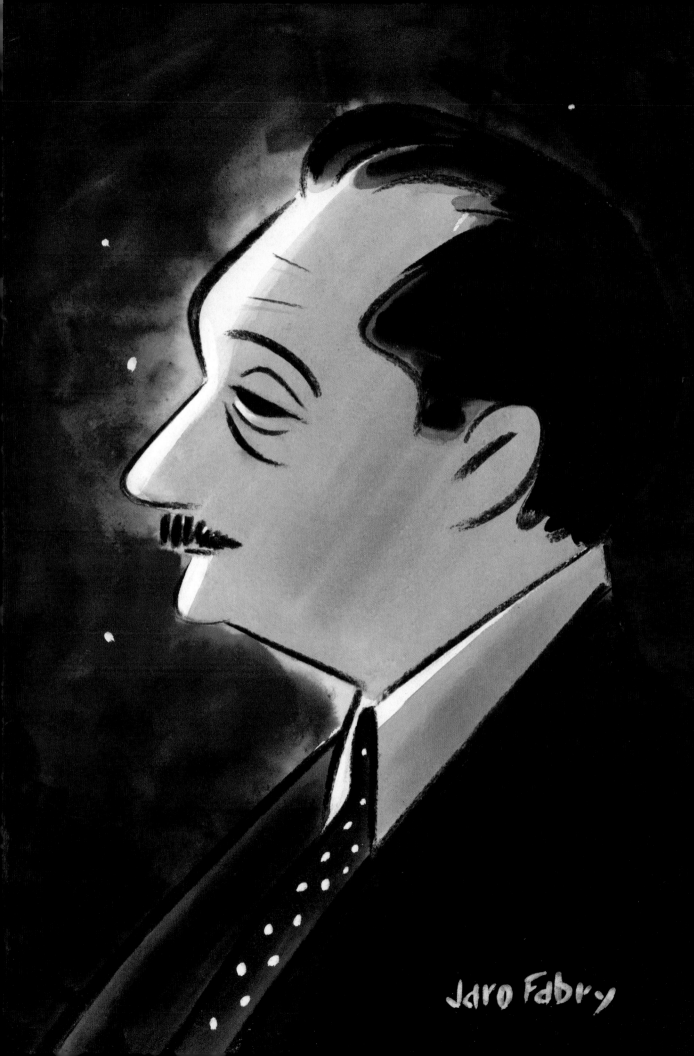

the art of fashion, style, and hollywood in the 1930s and 1940s

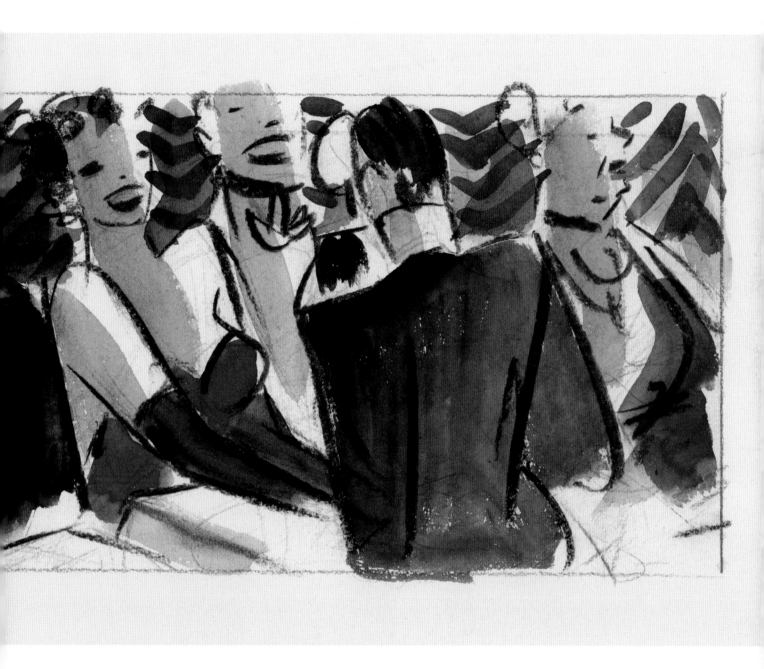

Left and right: the Duchess and Duke of Windsor, both conte crayon and watercolor on paper. Opposite page: backstage at Cole Porter's *Anything Goes*, 1934, conte crayon and watercolor on paper.

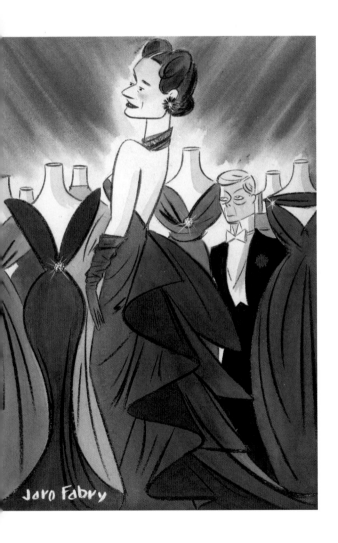

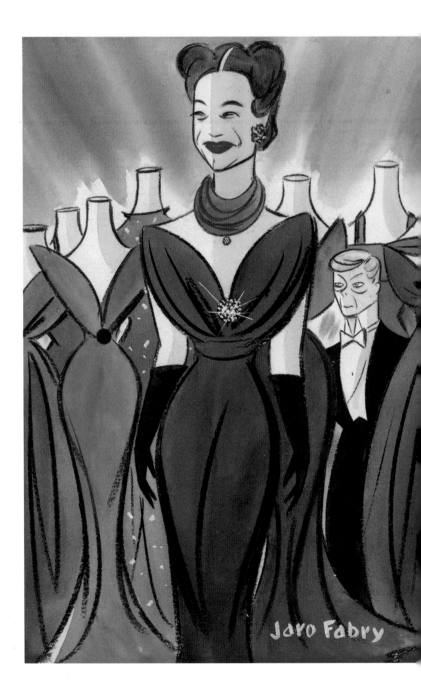

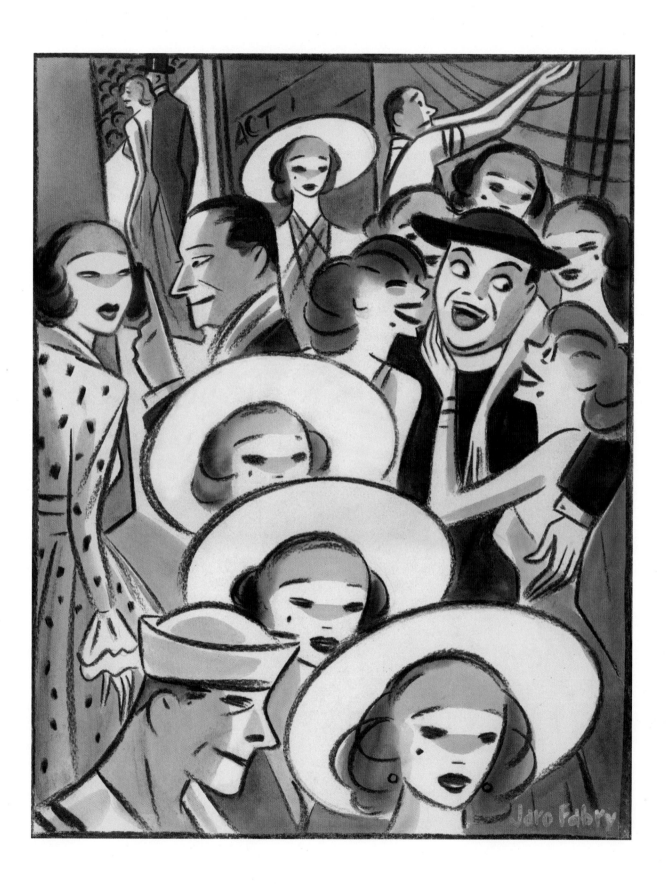

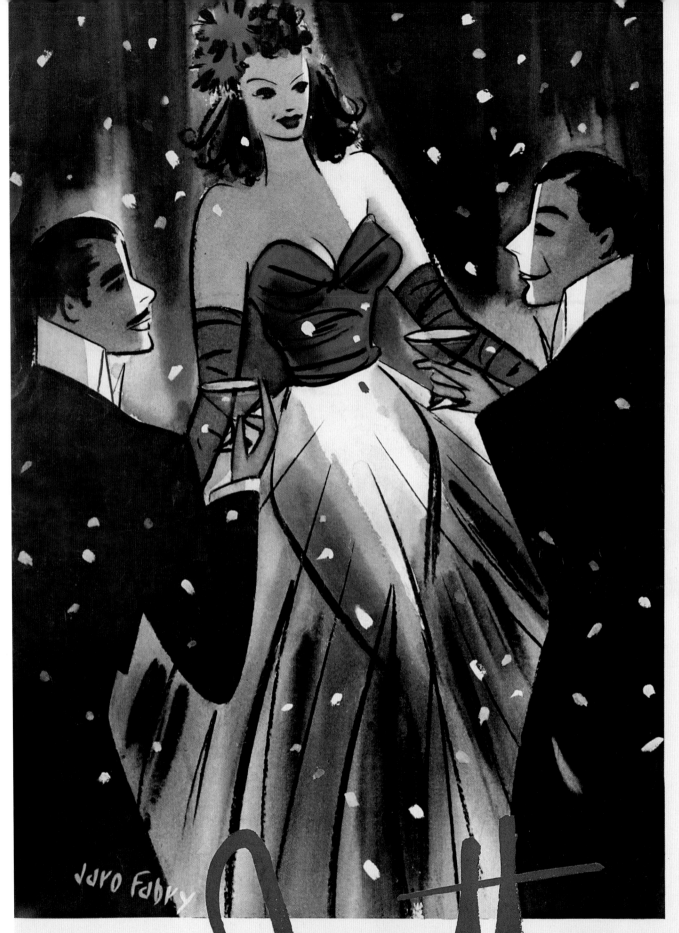

Jaro Fabry

Josette

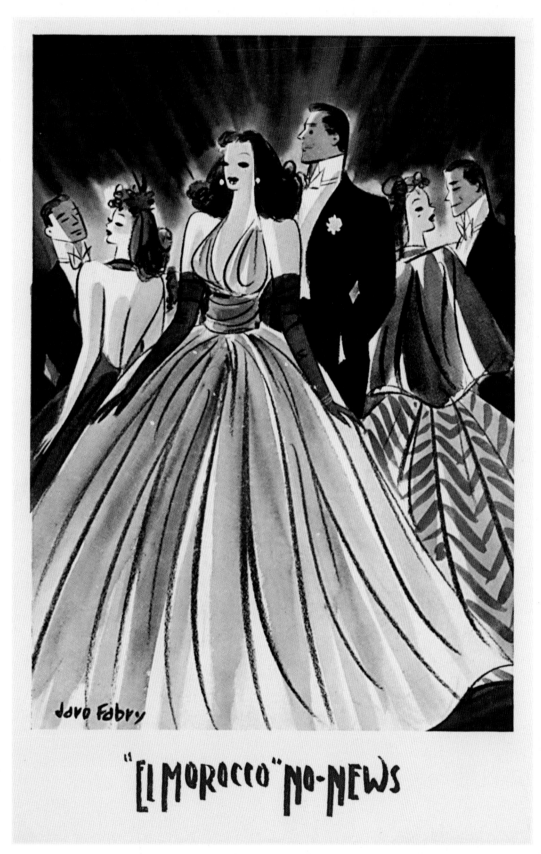

Above: El Morocco night club magazine cover. Opposite page: Josette cabaret program cover.

"TIM" DURANT'S

"T"IM" DURANT'S back in town, but he's not as dapper as when he was Adelaide Hutton's husband and lolled in the swell cars her fortune bought.

He may turn up at the Autumn Meet of the United Hunts at Belmont Park Election Day. He was an important official of the Hunts until Adelaide set him adrift. He went to Hollywood but had no luck.

Raymond Guest, president of the Hunts, is telling friends to bring their hip flasks to the Meet because the Turf and Field bar won't be open.

Students' Party

Princeton students are throwing a cocktail party for their gala at the 9 O'Clock Club this afternoon. They won't go back in a private car because they couldn't agree on the time. The shindig—two orchestras will play—may last until midnight. Harvard, Yale and U. of P. undergraduates will hold similar bouts during the Fall

Rear Admiral and Mrs. Clark Woodward will hold a reception for Admiral and Mrs. Yarnell at the Officers Club, of the Brooklyn Navy Yard Friday afternoon. The Yarnells recently returned from Newport where they were honored at numerous dinners.

Nancy Handy Debut

Nancy Handy will make her debut at the Tuxedo Ball Oct. 21. Daughter of the Truman

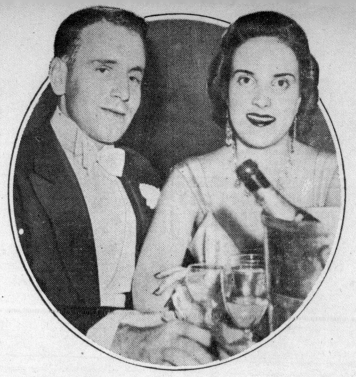

Parker Handys, of 23 E. 74th St., she will be presented by her uncle and aunt, the Cecil Bakers, with whom she will be a house guest of Mrs. C. Frederick Frothingham at her Tuxedo villa. Nancy will be formally presented at a dinner dance before the last Junior Assembly.

The annual Stag Dinner preceding the Monmouth Hunt

Meet will be ___ at the Rum ___ Amory L. Has ___ master. The ___ J. Wright Bro ___ at a ladies' d ___ Bank estate. ___ ing the meet, ___ kell will hol ___ cocktail party.

Marion Oates and Jaro Fabry formed a congenial twosome at El Morocco's first night. Photos by Dick Sarno of the Daily Mirror.

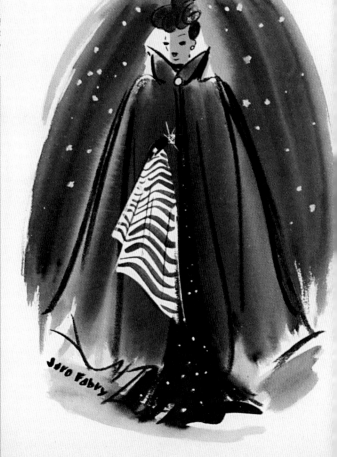

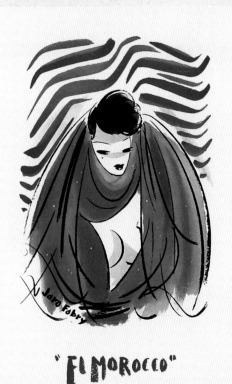

"El Morocco"

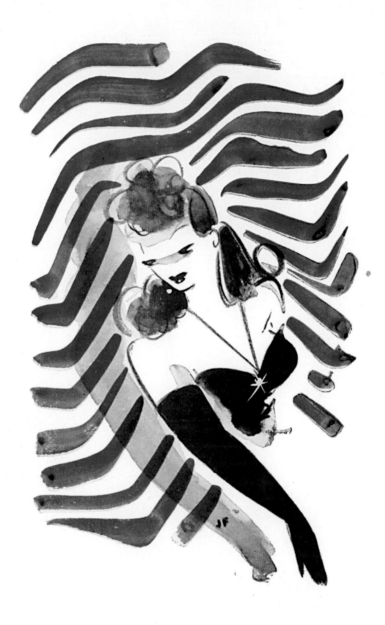

"EL MOROCCO"

Above and opposite page: newspaper clipping featuring Fabry and
socialite Marion Oates and a collection of illustrations for El Morocco.

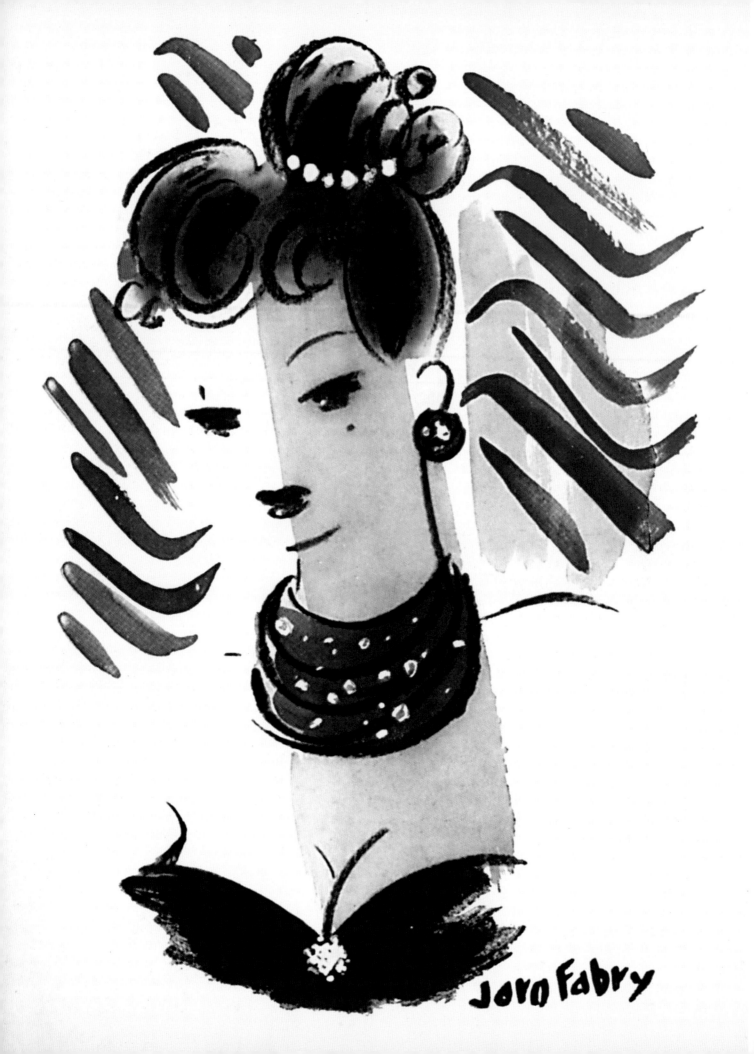

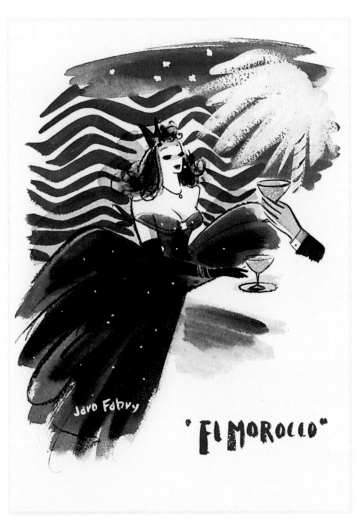

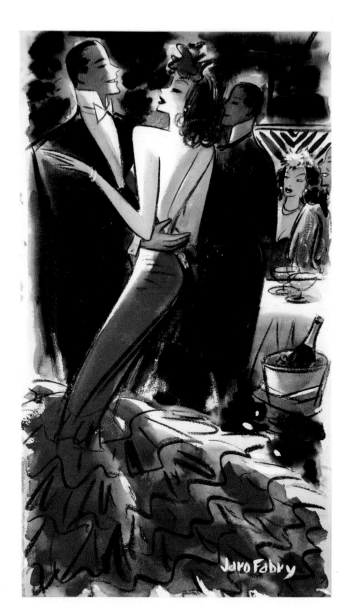

Above: El Morocco promotional illustration. Right: illustration for a fictional story taking place at El Morocco, conte crayon and watercolor on paper. Opposite page: El Morocco promotional illustration.

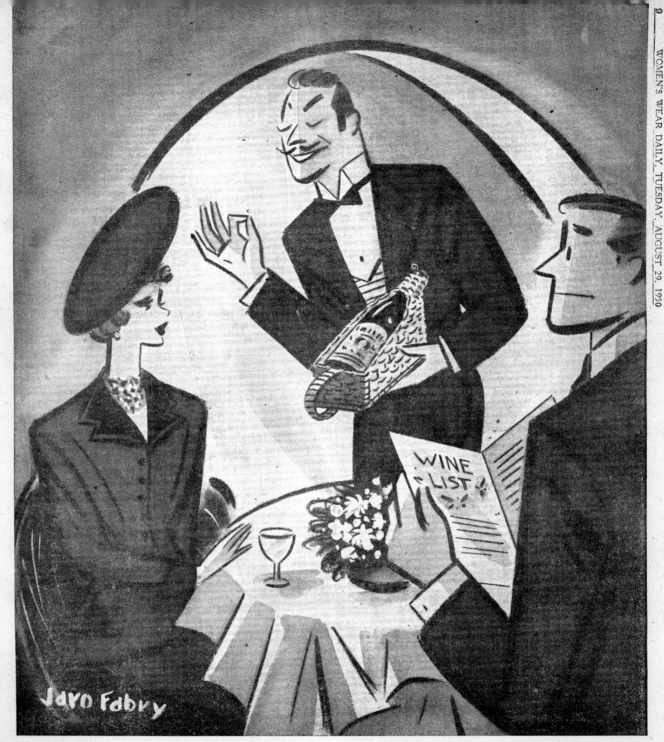

Jaro Fabry

Perfectly tailored suit in Sheen Gabardine . . . Fabric by Pacific Mills, Worsted Division

...but <u>this</u> is the real thing!

Of course the wines on the left-hand side of the wine-card are palate-tickling and pleasant—but there's something extra special when you're treated to the *real thing!*

And just as great vintages overshadow wines of lesser heritage, so it is with fabrics for fashion . . . for here, as any fine designer knows, *only wool* can do wool's job. Only wool has the unique blend of softness, strength, enduring good looks, lasting satisfaction, that add up to high fashion.

Pacific's famous Sheen Gabardine is the knowing choice among wools—with its crisp surface and unsurpassed hand, its range of intoxicating colors, the brilliance of its tailoring qualities. Like every one of Pacific's great woolens and worsteds, Sheen Gabardine's excellence is *natural*—stemming from the deep-rooted, inherent quality of wool itself. No wonder Sheen Gabardine puts such a sparkle in the eyes of top designers—makes customers out of connoisseurs!

Pacific
Craft Fabric
100% VIRGIN WOOL

It's a *PACIFIC* fabric

BY PACIFIC MILLS • WORSTED DIVISION • 261 FIFTH AVENUE, NEW YORK 16

chapter five
advertising

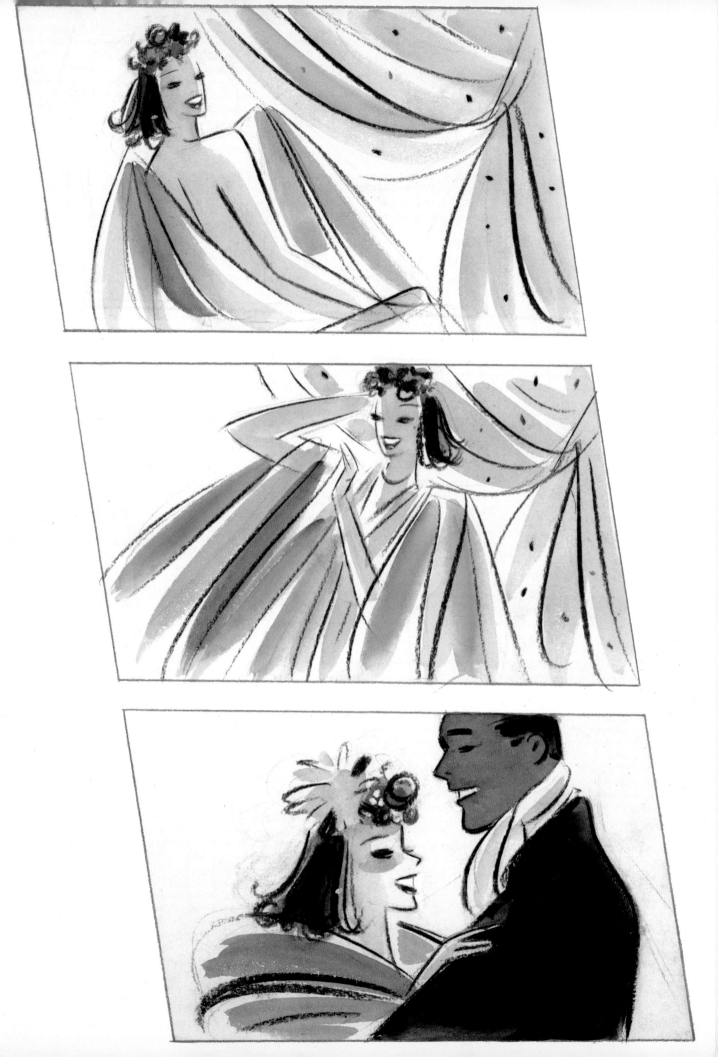

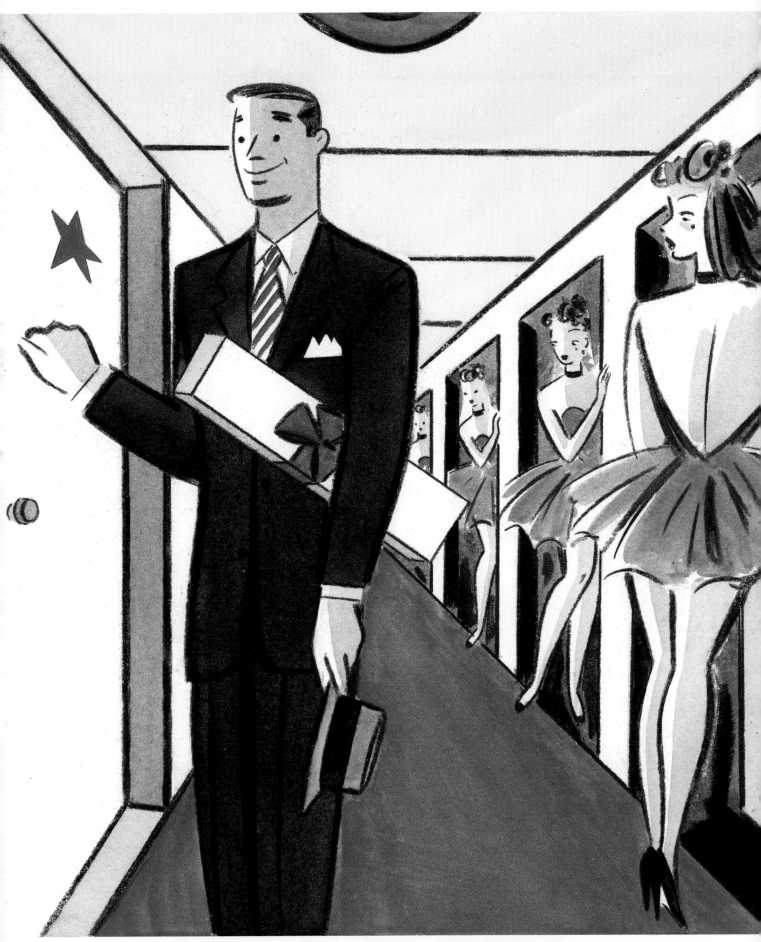

Previous two pages: *Women's Wear Daily* ad for Pacific fabric, August 29, 1950. Above: Pacific fabric ad, watercolor on illustration board. Opposite page: preliminary artwork for ad, conte crayon and watercolor on paper.

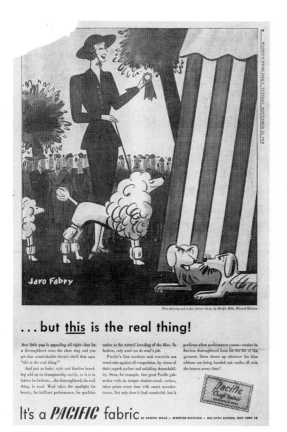

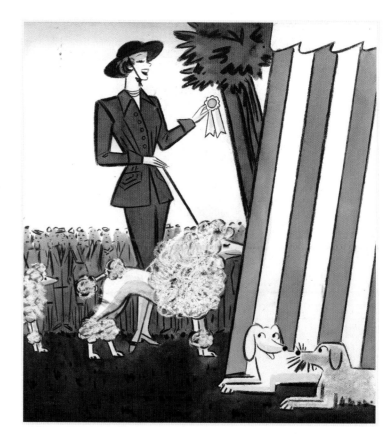

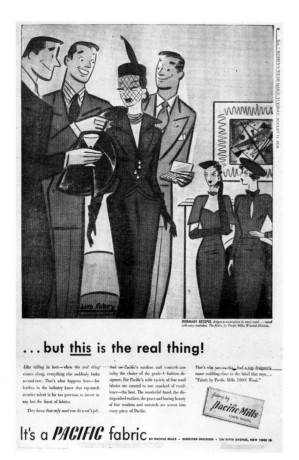

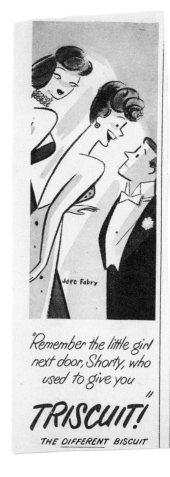

Top left: *Woman's Wear Daily* ad for Pacific fabric, April 12, 1950. Right, alternate artwork not used for the ad, conte crayon and watercolor on paper. Below left: *Woman's Wear Daily* ad for Pacific fabric, April 15, 1950. Right, Triscut ad. Opposite page: preliminary ad art for April Showers talc, conte crayon and watercolor on paper.

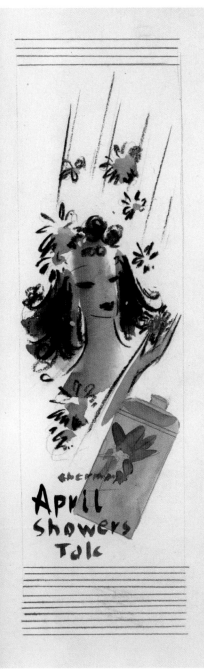

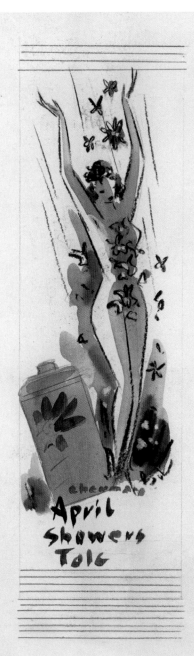

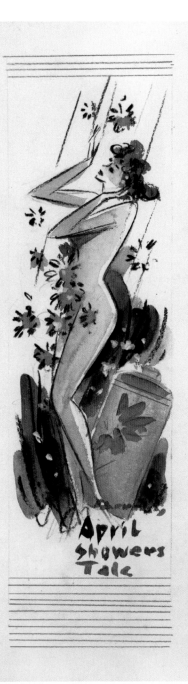

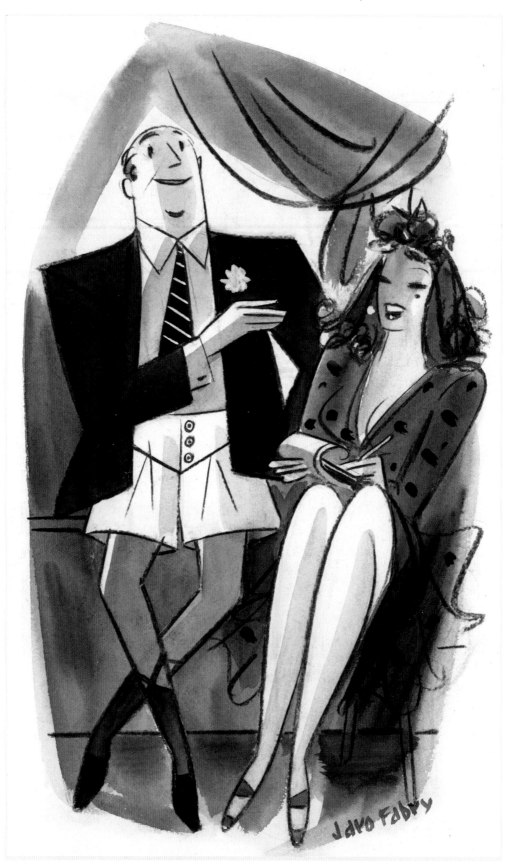

Above: ad for Gripper fasteners, conte crayon and watercolor on paper.